POSTCARD HISTORY SERIES

South Carolina Postcards

VOLUME VII
KERSHAW COUNTY

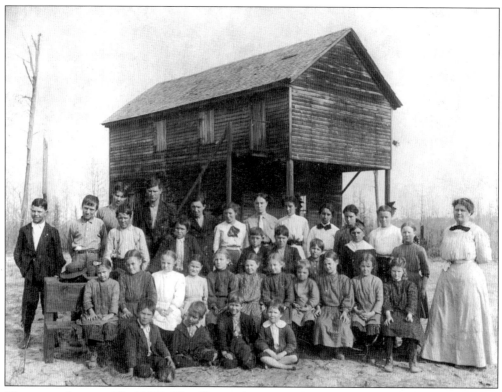

[SHAMROCK SCHOOL, C1, 1912]. The Shamrock Baptist Church sanctuary was erected in 1911, and in 1912, the Shamrock School was built near the church with both facing Porter Road (KC #42), one mile south of Bethune Road (SC#341), at Shamrock Road. This one-room frame structure is not typical of the first schoolhouses in this era because a special second-story room was added for Junior Order meetings. The 1912 picture above shows the one-room school, the initial enrollment of diverse ages and grade levels, and the first teacher, L. Britton. By 1913, the enrollment had expanded to 67 students in 8 grade levels for a 90-day term. Images, captions, and county educational data will illustrate this growth in each section of the county.

FRONT COVER:
[THE GENERALS' RACES AT BOYKIN, C. 1939]. The leaders of southern Kershaw County developed a second sports area, Boykin (Camden being the first), for the county during the turn into the 20th century. Clubs for sponsoring traditional social, cultural, and sporting activities like horse shows and racing events, drag hunts, dog trials, and other ventures that were begun in the early plantation days, were continued and expanded in Boykin. The races became known as the Generals' Races, with each named after one of the six Confederate generals born in this county. The cover picture shows Moultrie Burns holding the reins of the horse and speaking to Whit Boykin. Later in the 1940s, when army troops were encamped and holding maneuvers across Kershaw County, General Patton attended Boykin's races (1941) and enjoyed the gentile sportsmanship of these events.

BACK COVER:
[HAULING WOOD, CAMDEN C. 1900]. This turn-of-the-century image shows a typical scene where wood or other goods were being delivered to a Camden home or business. The less-expensive ox was the main beast of burden for families of limited means.

POSTCARD HISTORY SERIES

South Carolina Postcards

VOLUME VII
KERSHAW COUNTY

Howard Woody and Davie Beard

ARCADIA

Published by Arcadia Publishing,
an imprint of Tempus Publishing, Inc.
2 Cumberland Street
Charleston, SC 29401

Printed in Great Britain.

Library of Congress Catalog Card Number: 2001093948

For all general information contact Arcadia Publishing at:
Telephone 843-853-2070
Fax 843-853-0044
E-Mail sales@arcadiapublishing.com

For customer service and orders:
Toll-Free 1-888-313-2665

Visit us on the internet at http://www.arcadiapublishing.com

DEDICATION

For my children: Faun, Chris, Ceyelle, and Shoyl. —HW
Special thanks to Kershaw County historians, past and present,
Joanna Craig, and Wayne Porter. —DB

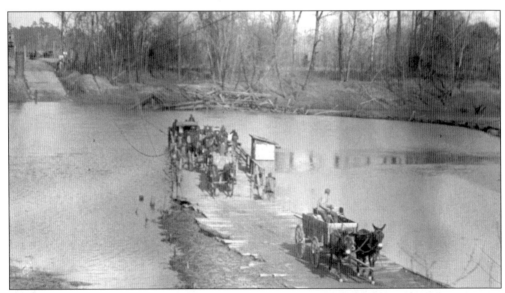

THE FERRY AT WATEREE RIVER AFTER THE 1916 FLOOD. After the major floods of 1908 and 1916 washed away the only bridge across the Wateree River, a toll ferry took its place to permit travel on the main road linking Camden to Columbia. A plank ramp from a high level was placed to the edge of the river on both sides. The ferry consisted of two flat boats tied together that could carry a few teams per load. A set of ropes were attached to both sides of the river and the barges were pulled from side to side during the hours of operation, which was a very slow process.

CONTENTS

INTRODUCTION

The search for historical images that reflect the evolving culture of each South Carolina county at the beginning of the 20th century continues with Kershaw County, volume seven. This South Carolina Postcards series, which began with related multi-county volumes, followed a pathway starting in Charleston (volume 1), then shifted south to Beaufort and the Lowcountry (volume two), before moving to Aiken and the West Central section (volume three). When this journey entered the "Midlands," an unexpected depth of postcard-type images was uncovered. Therefore, a decision was made to shift to single-county books that began with Lexington County (volume four), then Richland County (volume five), and Newberry County (volume six). Kershaw County (volume seven), extends the route eastward and continues the search for the visual images that document the unique aspects of each county in the "Midlands." The section below presents a brief review of the evolution of this county.

In 1902, the boundaries of Kershaw County faced Richland and Fairfield Counties in the west and Lancaster County in the north. The Lynches River became the eastern border with Chesterfield County, and finally, the southern boundary line abuts Lee, Sumter, and Richland Counties. The current Kershaw County area was originally a part of Craven County established in 1682. At the state's second division into districts, it was part of the Cheraw District in 1757, which was followed by the Camden Judicial District of 1769 and the Claremont District of 1785. Its basic boundaries were fixed by 1798. The actual boundaries between Lancaster and Lee Counties have shifted several times in recent years. Kershaw County is located at the western edge of the coastal plain, in the north central section of the state. The county's 705 square miles (in 1910) includes both swamps and a sand hill terrain. The Wateree River, a navigational waterway up to the fall line, was used in the colonial era to ship goods from Camden to Santee River wharves, and then on to Charleston. The county was named after Col. Joseph Kershaw and ranked 20th in land size in 1910.

Siouan-speaking Native Americans inhabited Kershaw County from 800 AD to 1700 AD. The Wateree River Indians, a branch of the Siouan Native Americans, had a camp at the fork of the Big and Little Pine Tree Creeks. The Catawba Nation had moved to their York site by 1743.

After Charleston was established, King George II of England gave instructions in 1730 to mark out places for 11 inland townships for the immigrant colonists on the rivers of South Carolina that included the Wateree. European families settled along the Wateree River banks near Camden, and were soon joined by a group of Irish Quakers, c. 1750. Scotch and Scotch-Irish settlers that traveled south on the Great Wagon Road from Virginia, Maryland, and Pennsylvania built farms on both sides of the Wateree, while others settled on the Lynches River.

Joseph Kershaw (1728–1791) had a tract of 150 acres surveyed in 1758 that included a site called Pine Tree Hill. Kershaw began establishing his mercantile business, a grist, and a sawmill; exported flours; and milled goods during the next decade. Initial commercial crops grown in the area were wheat, corn, cotton, hay, barley, and tobacco. Pine Tree Hill later became Camden. The name Camden was first in print in 1768 in an act of the South Carolina Assembly. Kershaw chose the name to honor Lord Charles Pratt, First Earl of Camden, a colonial rights champion. The first courthouse and gaol (jail) were built in 1771. Camden became the oldest inland town in the state. The Legislative Act of 1791 incorporated the town, the second after Charleston. Joseph Kershaw is considered the father of Camden.

Inland colonial sites in Kershaw County owed its early existence to its location on a navigable waterway below the fall line. The county's river travel to Charleston first used the Wateree and Santee Rivers by way of its mouth in 1786. Steamboat travel was in use by the mid-1830s. Land travel to Charleston in 1824 used a stage line that took several days in good weather each way. In 1848, railroad travel began first by using an indirect spur line that connected Camden to the South Carolina Railroad, which went from Charleston to Columbia. Later lines connected Camden to other major towns.

Kershaw County's movement into the 20th century followed the evolution of its rural education system and the eradication of illiteracy. The county's 1901 rural school system for its 5,664 students existed in 58 white and 49 black 1-room schools. The growth and amplification of instructive resources began with the establishment of school libraries in 1904 and continued when the number of high schools increased from 1 to 8 and school districts went from 26 to 47. Modern consolidation became more effective when school attendance increased and when the county's use of school buses increased to 34 in 1935.

Some have asked about the pictures in these books. Where were they found? What is a postcard image? The answers relate to the intended or extended use of the subjects on the photographer's negatives. Initially, pictures were taken for announcements, advertisements, documentation, newspaper, or family uses. These images could be made full scale for postcards, enlarged for framing, or reduced for montage uses. Probably the most interesting images relate to the extended uses of the negatives. Photographers wanted to make as many pennies from each negative as possible. Most of the views in this volume fit into the latter "extended uses" categories.

In order to select images for this volume, we asked two questions. Has the subject been seen before on a South Carolina postcard? Does the image have a historical or cultural value for South Carolina history teachers, students, and the public in 2002? Images came from archives, private individuals, members of historical societies, and postcard collectors' albums. Many were copied at public meetings in the county and elsewhere.

The scales of the pictures on the cover and in the book have been altered to relate to page layout and length of caption. Additionally, "titles" that appear on the front of some postcards begin each accompanying caption, but some have no titles or incomplete titles. For these, the authors have created a caption title and inserted it between brackets.

The object of the previous books in this South Carolina Postcards series has been to produce a body of images that reflect the pre-1900 to 1930s culture of a county. We hope that the two-fold experience of edification and enjoyment is found in this volume.

—Howard Woody and Davie Beard

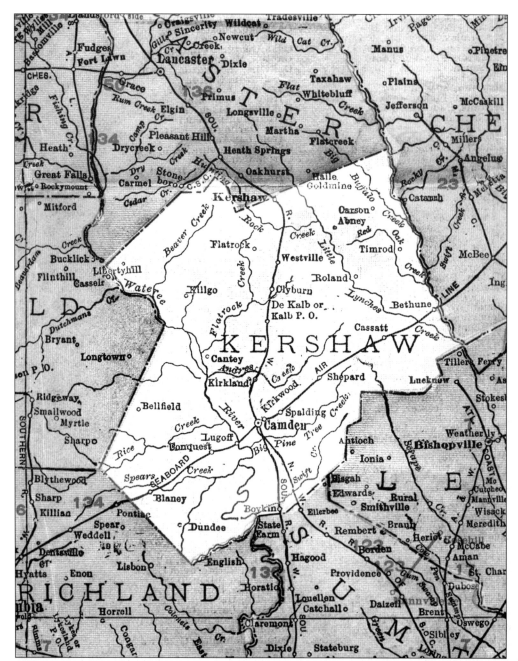

[MAP: KERSHAW COUNTY, 1910]. This map shows the boundaries of Kershaw County and the adjacent counties as they existed in 1910. Small rural communities that no longer exist are indicated along with the creeks, rivers, and railroad lines. Sections of a 1939 Kershaw County Highway map are found on pages 60, 68, 82, 91, 98, and 110 and include roads. Symbols for these roads are used in the captions: US# (federal), SC# (state), and KC# (county). Road names for 2002 are used in the text. The county maps have larger letter and number codes for school locations.

One

KERSHAW COUNTY'S INDIAN PEOPLES

The Mississippian Native Americans of central South Carolina were mound builders during 800 AD to 1700 AD. It is believed that these people spoke a Siouan language that is related to the tribes of the Great Plains. The travel accounts of European explorers, beginning with Hernando de Soto's 1540 expedition, present an intriguing possibility that the site where de Soto found the Cofitachequi was on present-day Mulberry Plantation on the Wateree River. Cofitachequi is the name for the central town of a province of allied people, which covered most of central South Carolina and a large part of North Carolina. These people were organized into a matriarchal society, whose elders included women in the ruling class. Other mentions of the Mississippian people are found in the journal of Juan Pardo, Spanish explorer of the southeast in 1567. The province of Cofitachequi existed until the 1680s, 10 years after Charleston was founded. In 1701, when English explorer John Lawson walked along the Wateree River, he found only a small group of surviving native people who did not speak of a connection to Cofitachequi. Lawson found the Congaree people in the Camden area. He met the Wateree Native Americans some 35 miles north of Camden. The Mulberry Plantation site is considered one of the most densely populated and important sites of native culture in the Southeast. The Siouan people were decimated and displaced in the early 18th century as a result of slavery, wars, and European diseases. The survivors coalesced into the Catawba Nation. By 1743, they had moved to the Catawba Nation site in York County.

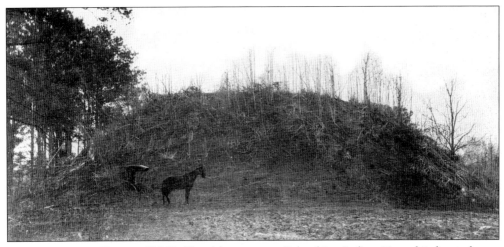

[ADAMSON INDIAN MOUND, 1901]. The Adamson pre-Columbian Indian Mound is located near Camden on the east bank of the Wateree River. The mound is an example of a flattop construction, which was used as a site for a temple rather than a burial mound. No official major archaeological excavation has been conducted at this site. Fragments of Native-American pottery from different early periods have been found.

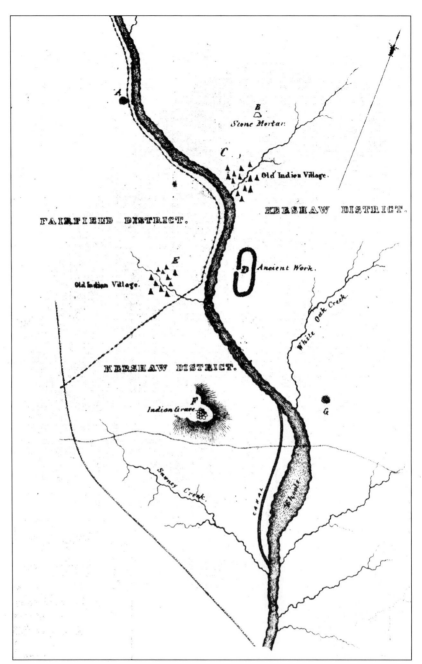

[**DR. WILLIAM BLANDING'S MAP, UPPER WATEREE RIVER INDIAN SITES, PUBLISHED IN 1848**]. Col. John
Barnwell's map of 1715, located the Waterees on Sawney's Creek, about eight miles north of
Camden, on the west side of the river. Later maps showed this town site as "old Wateree town."
By 1771, Mouzon's map indicates a Catawba village at the fork of the Big and Little Pine Tree
Creeks, which is also shown on John Kershaw's plat map of 1796. This Blanding map of the
upper Wateree River Indian Sites begins near Sanders Creek, and extends north past Grannies
Quarter Creek, White Oak Creek, and Beaver Creek. Evidence of villages, mounds, and other
sites are shown on the 1848 map, although these sites were abandoned at that time.

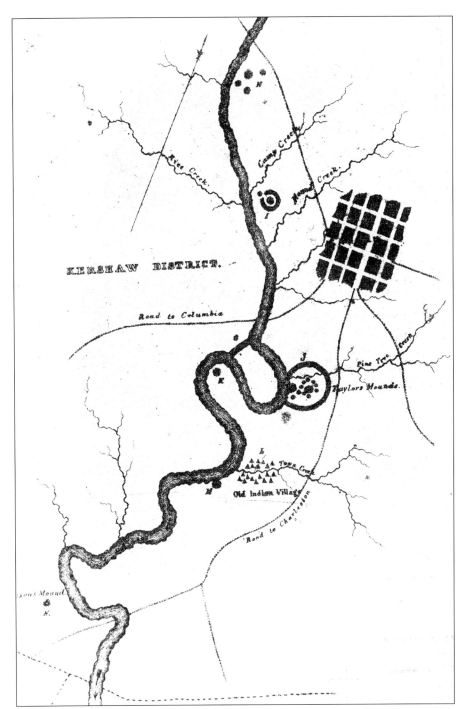

[DR. WILLIAM BLANDING'S MAP, LOWER WATEREE RIVER INDIANS SITES, PUBLISHED IN 1848]. This map of the Wateree River sites of Native-American occupation begins near the Sumter County Line and continues north. It includes a Native-American village at the mouth of Town Creek and mounds at Belmont Neck and Taylor Field on Mulberry Plantation. Archaeological investigation has revealed that the Taylor site had a circular stockade around the village.

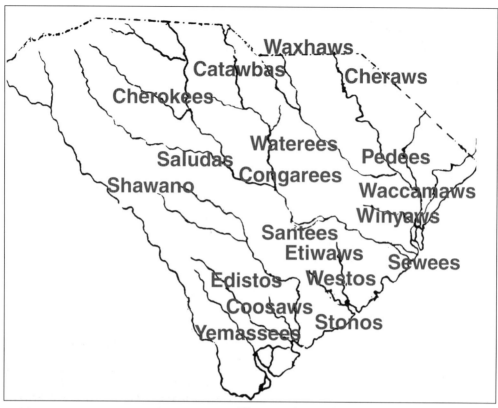

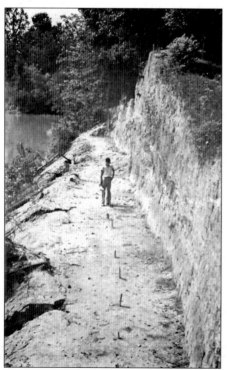

[CHART OF SOUTH CAROLINA NATIVE AMERICANS, *c.* 1900]. The Mississippian people inhabited the central South Carolina area from the coast to North Carolina along the Santee, Wateree, and Catawba drainage areas. They included the Sewees, Santees, Congarees, Waterees, Waxhaws, Catawbas, and others. The Cherokees, a branch of the Iroquois-speaking people, and other tribes along the Savannah River, were part of the Creek Nation, inhabitants of coastal Georgia, and the Gulf States. In the Augusta area, there lived the Shawano tribe, a branch of the Algonquian people from whose name the Savannah River evolved.

[EXCAVATION OF TAYLOR INDIAN MOUND *c.* 1985]. The pre-Columbian mound at Taylor field on present-day Mulberry Plantation is near the junction of Big Pine Tree Creek and the Wateree River. In 2002, it is largely washed away by the river. Some historians believe this site was once Cofitachequi, the central town of the Mississippian people living on the Wateree-Santee drainage between 800 AD. The first archeological excavation of the Taylor site occurred in 1891.

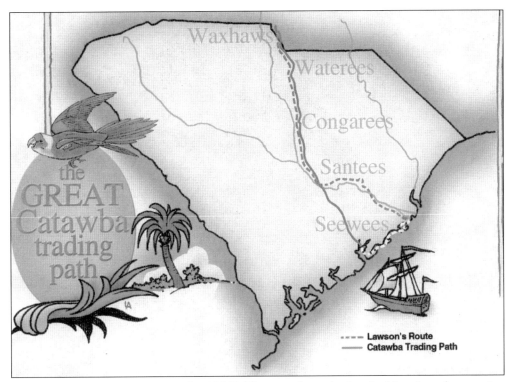

THE GREAT CATAWBA TRADING PATH [C. 2000]. The map above depicts the historic path—crossing through Camden and Kershaw County—named for the Catawba Indians. It was used by early Native Americans for a thousand years as they traveled down the rivers to the coast. In the 1700s, native people traveled from hunting grounds to trade deerskins with the Europeans. The English explorer, John Lawson, followed this path in 1701 as shown on the map.

[HIGH HOUSE, MULBERRY, C. 1929]. High House stood on the Belmont Neck Indian Mound, which was initially a flattop mound on which native people may have erected a ceremonial structure. In the view above, the overseer's house is built on tall brick pillars, on top of the low mound. In 1929, Steven Miller Williams reorganized Mulberry for his son, David R. Williams IV, and installed David Brisbane in High House as an overseer. The house no longer stands.

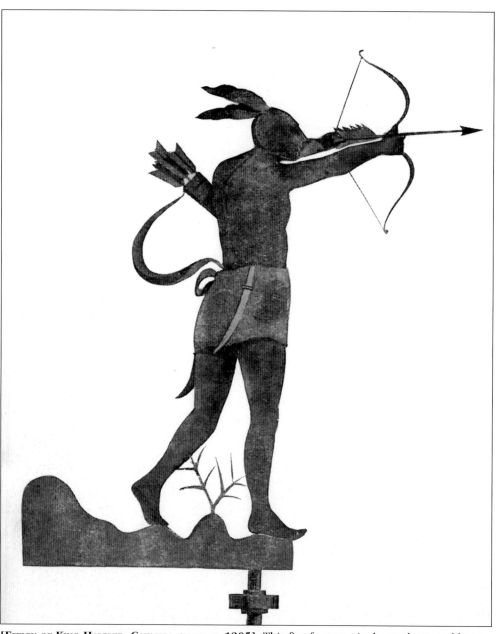

[EFFIGY OF KING HAIGLER, CATAWBA CHIEF, C. 1905]. This five-foot one-inch weathervane likeness of King Haigler (1730s–1763) was made c. 1826. Haigler was the king of the Catawbas and became good friends with Camden's Quaker leader, Samuel Wyly. He and the Catawbas protected the colonists during an Indian war. In 1763, Haigler was killed in an Indian conflict. Both the colonists and Catawbas mourned his death. J.B. Mathieu designed the iron effigy of Haigler and gave it to the town. It was placed on the Market Place Tower, the highest position. Haigler, called "The Patron Saint of Camden," is considered the town's guardian. The original weathervane resides in the Camden Archives and Museum.

Two
MILITARY HISTORY

The Revolutionary War (1775–1783) came to Camden when it was occupied on June 1, 1780 by British troops. Before the Battle of Camden, their troops had expanded to 1,700 infantry and 300 cavalry, led by Lord Cornwallis. Fourteen battles were waged in this vicinity, including the Battle of Camden. The armies met at Sanders Creek or Gum Swamp on the morning of August 16, 1780. Continental losses were 1,000 killed or wounded. The British had 300 killed or wounded. The second battle at Hobkirk Hill on April 25, 1781 ended with 260 American troops killed or wounded. The British casualties were similar. The occupation lasted almost a year before the people of the town returned in 1781, after some of it was burned by the British.

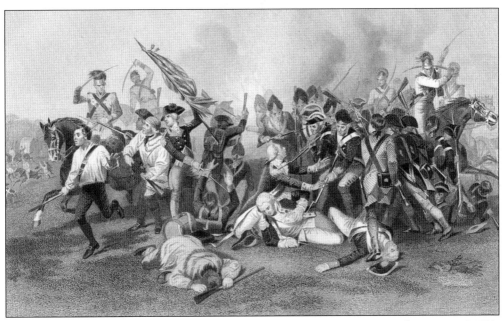

[BATTLE OF CAMDEN, AUGUST 16,1780, BY ALONZO CHEPPEL (1828–1887)]. In the spring of 1780, South Carolina was under British control with no Continental army south of Virginia. Troops from Maryland and Delaware, along with some Virginia and North Carolina militia under Maj. Gen. Baron deKalb, moved south with few supplies. Gen. Horatio Gates took command in North Carolina. When they arrived at Grannies Quarter Creek, 15 miles above Camden, Gates had 3,052 travel-weary men. In the morning, the British advanced, creating a panic in the weakened Continental troops. The left flank suddenly fled the field with General Gates close behind them. The outcome became the worst Continental defeat of the entire war.

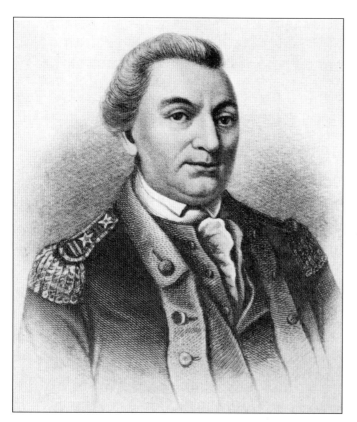

[PORTRAIT OF BARON DEKALB, *c.* 1777]. Johann Kalb (1721–1780) was born in Huttendorf, Baveria, Germany, and became a professional soldier. He assumed the title of Baron and "de" during his long career in the French army. In 1777, Lafayette and deKalb left France to serve in the Continental Army as major generals and landed in Georgetown Bay. Three years later, General Gates and Baron deKalb met the British at the Battle of Camden and deKalb was mortally wounded.

DEKALB MONUMENT, CAMDEN, [1825]. Baron Johann deKalb (1721–1780) was a German soldier who served in the French army. In 1777, he was engaged by Lafayette to come to the American colonies and aid them during the American Revolution. DeKalb, under the command of Gen. Horatio Gates, was wounded, and died three days later in Camden. He was later reburied at the Bethesda Presbyterian Church and a monument designed by Robert Mills was erected in 1825 at that church. Lafayette laid the cornerstone to the monument in a Masonic ceremony held during his visit to Camden in 1825.

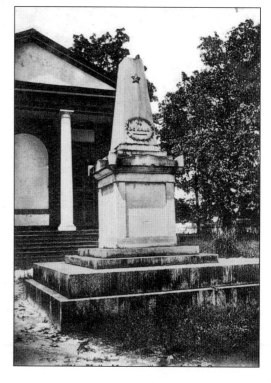

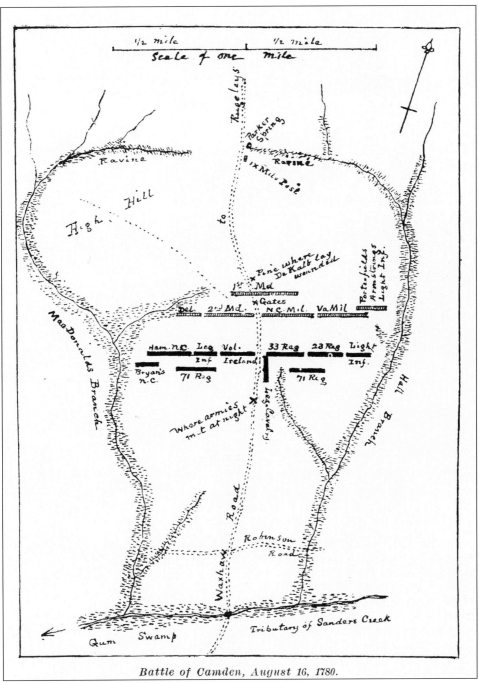

Battle of Camden, August 16, 1780.

[MAP OF BATTLE OF CAMDEN, C. 1880]. The first major Revolutionary battle near Camden between units of the Continental Army and British troops was fought nine miles north of the town. This map shows the positions of the British and Continental armies and notations of the topography. It was a major southern loss for the Continental Army. Baron deKalb's right flank was exposed to attack in its rear, and he was unaware of the rout as he commanded the remaining troops and was mortally wounded.

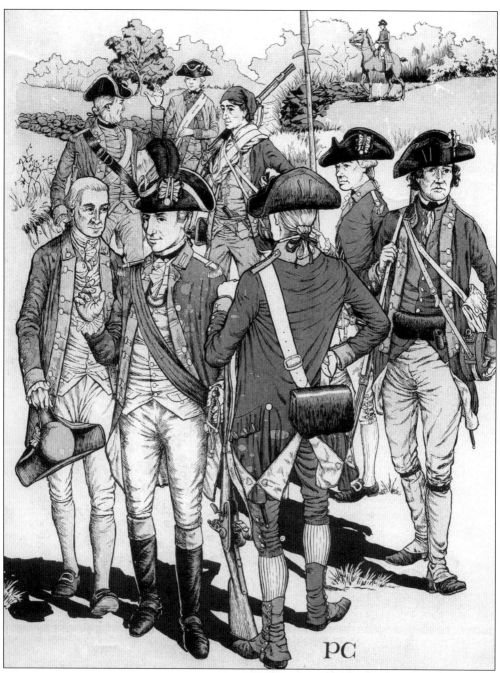

[REVOLUTIONARY UNIFORMS, PUBLISHED, COMPANY OF MILITARY HISTORIANS, C. 1990s]. This illustration shows the uniforms of the 2nd Virginia Regiment of the Continental Line, 1779–1780. Virginia troops fought at the Battle of Camden and Hobkirk Hill. The Revolutionary military men by rank beginning at the back group of four, from left to right, are Sergeant (1780), Fifer (1780), Private (1779), and Company Officer (1779–1780). The front four, from left to right, are Surgeon (1779–1780), Colonel (1777–1780), Private (1780–1781), and Private (1781).

[**Portrait of Lord Charles Cornwallis, by Thomas Gainsborough, *c.* 1770s**]. Lord Charles Cornwallis (1738–1805) was the eldest son of the First Earl Cornwallis. He entered the British army in 1757 and served in the Seven Years War in Germany. Cornwallis came to America as a major general in 1776 and became second in command the following year. He was the most successful British general in this war. His initial southern expedition of 1780–1781 was largely successful. However, he began moving north when the patriots' pressure began to close in on him. He was forced to surrender at Yorktown on October 19, 1781.

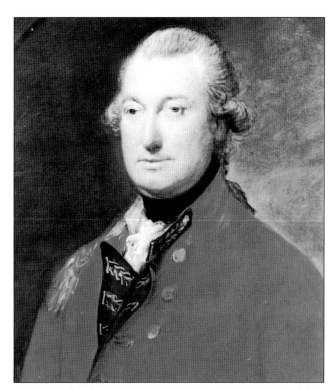

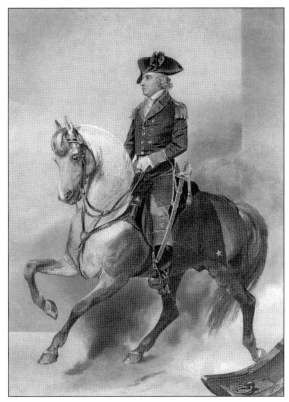

[**General Horatio Gates, by A. Chappel, *c.* 1880**]. Horatio Gates (1727–1806), a Continental general, was born in England, entered the British Army, and served in the American colonies in the French and Indian War. Later, Gates immigrated to the colonies in 1772. He sympathized with the colonials and became adjutant general of the Continental Army in 1775. In 1777, he led the northern troops and defeated Gen. John Burgoyne in two battles at Saratoga. In 1780, Gates was sent to the South and was tragically defeated at Camden. He did not serve again until 1782.

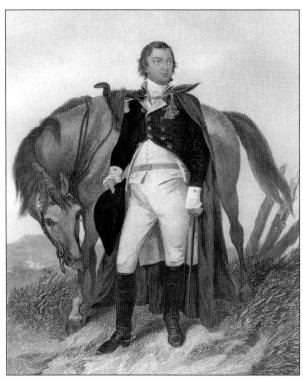

[GEN. NATHANAEL GREENE, BY A. CHAPPEL, C. 1880]. Gen. Nathanael Greene (1742–1786) was born in Rhode Island. The Continental Congress made him a major general in 1776. He served under George Washington and succeeded Gates as commander of the southern army at Charlotte, North Carolina in 1780. His several battles included a victory at Cowpens and a defeat at Hobkirk Hill; however, over-extended supply lines caused the British forces to evacuate from Camden.

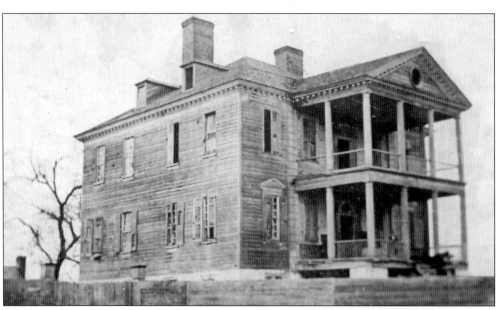

[KERSHAW/CORNWALLIS HOUSE, 1858]. Joseph Kershaw built this three-story Colonial Georgian mansion starting in 1777. Lord Cornwallis seized and used the house as British headquarters from 1780 to 1781. Kershaw died there in 1791 and his family sold the house in 1805. It became the home of the Camden Orphan Society until 1822. Later, it became a Confederate storehouse, which was destroyed in 1865. A reconstruction of it was erected in 1977 at the Historic Camden Revolution War Site.

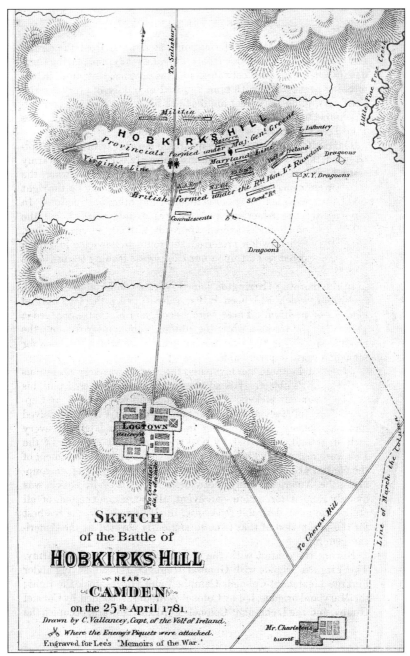

SKETCH
of the Battle of
HOBKIRKS HILL
⊷ NEAR ⊶
⸰CAMDEN⸰
on the 25th April 1781.

Drawn by C. Vallancey, Capt. of the Volt of Ireland.

⚔ Where the Enemy's Piquets were attacked.

Engraved for Lee's 'Memoirs of the War.'

[MAP, BATTLE OF HOBKIRK HILL, BY C. VALLANCEY, c. 1880]. The Battle of Hobkirk Hill, the second major Revolutionary battle at Camden, on April 25, 1781, was commanded by Gen. Nathanael Greene. His 1,400 troops were camped on Hobkirk Hill, two miles north of Camden. The 900 British troops under Lord Francis Rawdon quietly marched to the site and surprised the Continentals who quickly assumed their formation and, with deadly firing, surprised the British. By the end of the day, the Americans had the field. The British had engaged in several battles and were short of supplies because they were cut off on all sides. Fifteen days after the battle, the British set fire to Camden and left it in ruins.

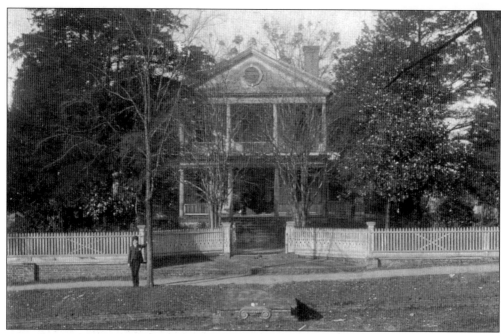

[LAFAYETTE HALL, C. 1900]. On March 8, 1825, General Lafayette was escorted from the North Carolina line by cavalry to Camden where he was met by local leaders. Lafayette resided in this home during his stay in Camden as he participated in the deKalb Monument ceremonies. Henry Cook built this residence in 1821 and sold it to John Carter in 1823. Later, it was the home of the Dunlap family. The house was destroyed by fire in 1903.

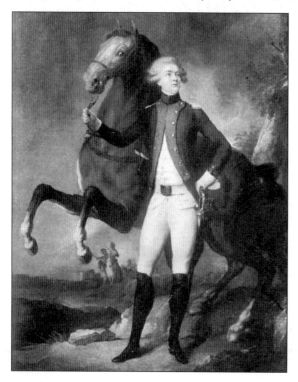

[PORTRAIT OF MARQUIS DE LAFAYETTE BY BOILLY]. Marquis de Lafayette (1757–1834) was a wealthy young French soldier, statesman, and hero of the American War for Independence. He arrived in Philadelphia in 1777 and joined Gen. George Washington's staff. In 1781, Lafayette headed the Continental Virginia army and helped drive Cornwallis' army to Yorktown. On a return trip in 1824–1825, he visited Camden and participated in the deKalb Monument ceremonies. L.L. Boilly (1761–1845) painted the image to the left.

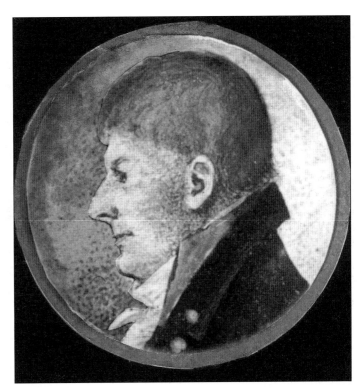

[MINIATURE PAINTING OF JOSEPH KERSHAW]. Joseph Kershaw (1728–1791) was born in West Riding, Yorkshire, England and came to Camden in 1758. By 1760, he was milling "Carolina" flour, which was then shipped to Charleston, and was the beginning of his fortune. Kershaw also built saw and gristmills along with mercantile businesses. He was a staunch patriot and was put in prison when the British took Camden and then deported. After the war, Kershaw returned to Camden. He lost most of his fortune and died in 1791. Kershaw is called the "father of Camden" and Kershaw County was named for him.

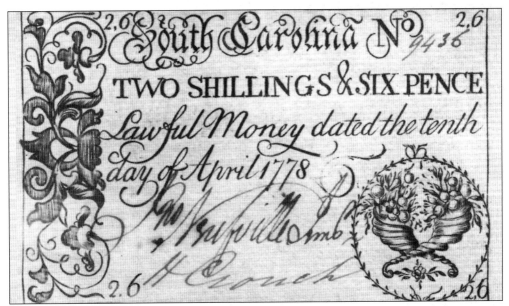

[TWO SHILLINGS AND SIX PENCE, C. 1910]. The South Carolina Provincial Congress selected state officials on March 6, 1776. On February 14, 1777, the South Carolina General Assembly authorized the series of bills including the one above. Each bore the signatures of the colonial officials. A Charleston engraver created the plates from which the paper currency was printed for use across the colony. Examples of this currency were photographed, enlarged, and printed on postcard stock c. 1910. Examples were found in a Camden postcard collection.

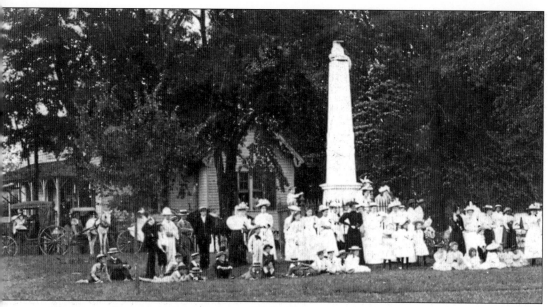

[DICKINSON MONUMENT DEDICATION, c. 1856]. This postcard, shown in two parts so readers can easily see all portions of it, depicts the funeral of Lt. Col. James P. Dickinson (1816–1847), who was born in Camden. At age 10, he was orphaned and raised in the home of his cousin, Dr. Alfred Brevard. Dickinson served under Capt. J. Chesnut in the Florida War. He was a member of the DeKalb Rifle Guard organized in Camden in 1846, when Dickinson was elected lieutenant colonel. The DeKalb Rifle Guard became a unit of the Palmetto Regiment during the Mexican

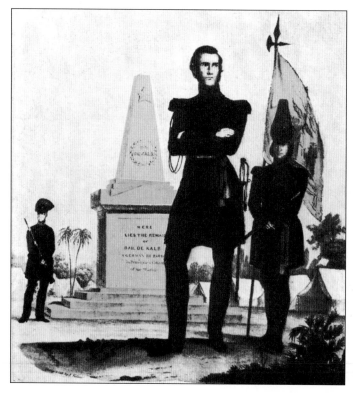

[RENDERINGS OF DICKINSON'S SPEECH AT THE DEKALB MONUMENT, 1846]. Lt. Col. James P. Dickinson joined the DeKalb Rifle Guards. On May 20, 1846, this company, including Dickinson and James Cantey, were among the first to volunteer for service in the Mexican conflict. On December 2, 1846, he gave an eloquent speech to encourage Kershaw men to enlist as he stood by the base of the deKalb Monument, which is portrayed to the left. In December, the "Kershaw Volunteers" became the Palmetto Regiment with Col. P.M. Butler and Lt. Col. J.P. Dickinson.

War. Dickinson was severely wounded at Vera Cruz and Churubusco and died at Mixchoac, Mexico in 1847. His remains were returned to Camden and an impressive funeral was held on January 22, 1848. A long procession included military and political groups, and bands were followed by eulogies and volleys of rifle fire. In 1856, the body was transferred to Monument Square where a handsome marble shaft monument was erected over his grave. The ceremony was similar to the 1848 event with volleys fired to honor Dickinson.

[POWDER MAGAZINE, CAMDEN, C. 1910]. The old Powder Magazine was built in 1859 at Market and Mulberry Streets, and was used before and during the Civil War for storing arms and powder. Its hollow walls were ventilated and kept the powder dry. During the Civil War, Camden became an important Confederate railroad terminal, storehouse, and hospital site until 1865, when Sherman's army burned some parts of the town and then occupied it for nine months. The Kershaw County Historical Society preserved this structure and gave it to the city of Camden.

MARION CADET BANNER, [1842]. The Marion Cadets Company, organized by Capt. Thomas J. Warren (1825–1863), was included in a Camden military parade on July 4, 1842. Warren, editor and proprietor of the *Camden Journal* from 1850 to 1861, wrote articles with an intense advocacy of southern secession. This company was included in the Kershaw Guards, Company D, 15th Regiment Infantry and fought in the battle of the Little Round Top at Gettysburg in July 1863, where Warren was killed. His remains were interred in Camden in May 1871.

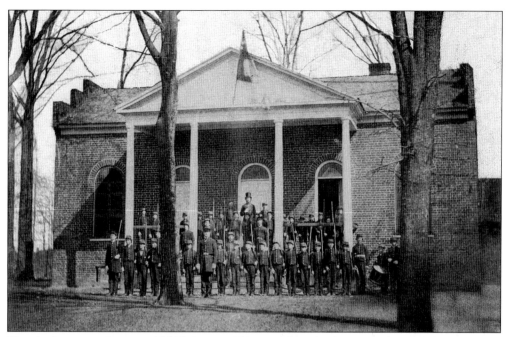

[**Peck's Academy, Camden, 1861**]. From 1859 to 1863, Charles H. Peck, a northern teacher sympathetic with the South, taught the male semi-military school in the Eastern Academy, one of two school buildings that James English had built in 1822. The war fever was strong among the academy boys who escorted the "Camden Volunteers" to the train heading to Fort Sumter on April 9, 1861. They began to enlist in the Kershaw Brigade immediately. Peck's Academy was closed during the Civil War. The academy buildings on DeKalb Street were used for about 70 years and demolished in 1909.

[**Gen. Zack C. Deas, CSA, *c.* 1870**]. Gen. Zack Cantey Deas (1819–1882) was born in Camden and moved to Mobile, Alabama in 1835. He served in the Mexican War. Deas began his Civil War service on the staff of Gen. J.E. Johnson. In the fall of 1861, Deas raised a regiment—the 22nd Alabama—and equipped it with 800 Enfield Rifles at a cost of $28,000 in gold. Deas led them in battle at Shiloh where he was seriously wounded. In 1862, Deas was promoted to command the Alabama Brigade, which fought at Chickamauga, Missionary Ridge, and Franklin.

[**Isaac B. Alexander, Designer of the Secession Banner, *c.* 1840**]. Isaac B. Alexander (1812–1885) was the designer of the Secession Banner. He was a talented man who was an artist, jeweler, and photographer who had studied in New York. Alexander brought a professional, creative, and cultural presence to Camden and South Carolina. This portrait shows him as a young man proudly wearing several ribbons.

[**The Infantryman's Uniform, *c.* 1900**]. This painting by W.L. Sheppard (1833–1912) is on display at the Confederate Museum in Richmond, Virginia. The museum reproduced this image on a postcard in the 1920s. It is one of a popular series created for sale to collectors of Civil War memorabilia. Sheppard was a Confederate veteran and these images portray an authentic record of the uniforms of that era.

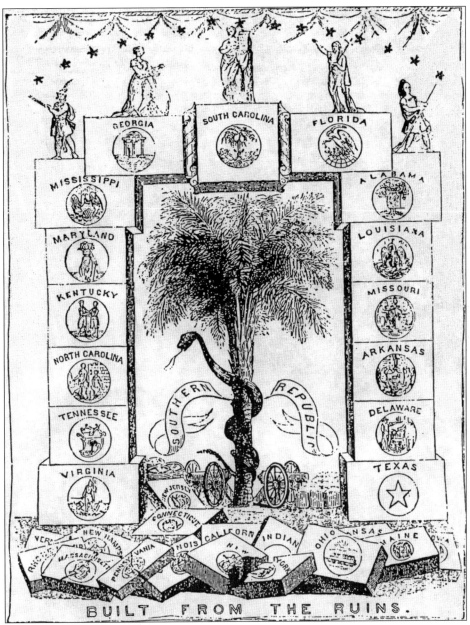

BUILT FROM THE RUINS.

BUILT FROM THE RUINS, [SECESSION BANNER, 1860.] This banner was designed and painted in 1860 by I.B. Alexander. The design places South Carolina as the keystone of an arch of 15 southern states. These states felt that their "property, prosperity, equality, and liberty" rights as stated in the 4th, 9th, and 10th rights in the Bill of Rights were being broken by the federal government. The other states that broke those rights are depicted at the bottom. The drawing in the center was adapted from an earlier Revolutionary flag. This banner hung in Institute Hall in Charleston above the table where the 170 peoples' delegates signed the Ordinance of Secession on December 20, 1860. The signing was witnessed by the entire South Carolina General Assembly. Later the banner was suspended over Meeting Street in front of the Institute Hall and the winter weather caused it to fade.

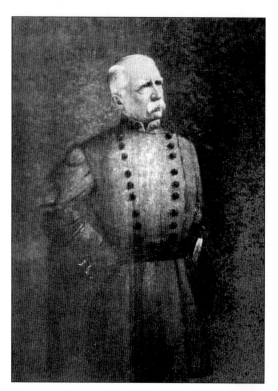

[GEN. JOSEPH B. KERSHAW, CSA, *c.* 1880].
Gen. Joseph Brevard Kershaw (1822–1894) and his regiment were present at the Fort Sumter bombardment in April 1861. His four companies formed the 2nd Regiment in the First Corps of the Army of Northern Virginia, which saw action at Bull Run, Harpers Ferry, Sharpsburg, Fredericksburg, Chancellorsville, Gettysburg, Chickamauga, and the Wilderness. After the war, Kershaw practiced law in Camden and was elected to the Circuit Court Bench.

[GEN. JOHN B. VILLEPIGUE, CSA, 1862].
Gen. John B. Villepigue (1830–1862) was born in Camden and graduated from West Point in 1854. While engaged in a conflict with Native Americans in Utah, South Carolina seceded and Villepigue resigned his commission, returned to Montgomery, Alabama, and enlisted in the Confederate Army. Villepigue served at Pensacola, Florida, Fort Pillow, and Corinth before contracting and dying of malaria at Port Hudson, Louisiana. He is buried in the Quaker Cemetery in Camden.

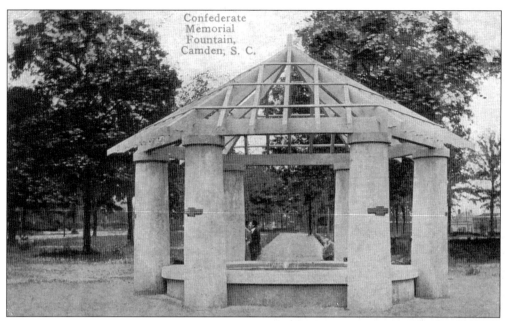

CONFEDERATE MEMORIAL FOUNTAIN, [1911]. The Pantheon Memorial in Rectory Square consists of six nine-foot tall columns supporting a pergola mantled with ivy and a fountain. Each column has a bronze tablet commemorating one of the six Confederate generals that had lived in Camden: James Cantey, James Chesnut (page 55), Zack Cantey Deas, John Doby Kennedy, Joseph Brevard Kershaw, and John Bordenave Villepigue. The $2,000 memorial was unveiled on May 10, 1911, to honor the six Camden schoolboys who attained the rank of general in the army of the Southern Confederacy.

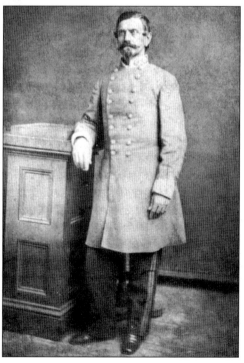

[BRIG. GEN. JAMES CANTEY, CSA, 1864]. James Cantey (1818–1873) was born in Camden and graduated from the South Carolina College in 1838. He served as adjutant in the Palmetto Regiment during the Mexican War and moved to Alabama in 1847. He joined the Confederate Army as a colonel of the 15th Alabama Infantry and served under Gen. Stonewall Jackson. In 1863, he was commissioned general of a brigade, which he led from Dalton, Georgia to North Carolina. He became a planter in Alabama.

South Carolina, Swamp Fighters {Sharpshooter}

SOUTH CAROLINA, SWAMP FIGHTERS [SHARPSHOOTER] [c. 1910]. This postcard image is one from several series documenting Confederate subjects that were drawn at the turn of the century to illustrate civil war military individuals, regiments, and events. Various companies and regiments from different states wore different uniforms.

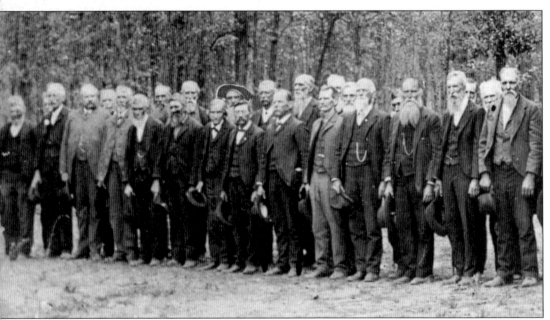

[CONFEDERATE VETERANS REUNION, 1914]. This image, shown in two parts so readers can easily see all portions of it, was photographed in October 1914. Confederate Veterans of Companies A, Lucas Guards, and F, Lucas Rifles (originally one company), 7th Battalion held a reunion in Bethune to honor Capt. Benjamin Simons Lucas II, their leader who was wounded, and lost an arm in the battle of Cold Harbor. Over 80 years old, he was too feeble to walk, so his comrades lifted him on their shoulders and carried him to this reunion, his last. In the image

CONFEDERATE MONUMENT, CAMDEN, [1908].
Camden's 1872 Ladies Monument Association proposed a monument to honor those who served in the armed forces of the Confederate States of America. Arnold Mayhew designed a 20-foot cylindrical shaft of Italian marble that was surmounted by an urn with a dove with outstretched wings. The $10,000 monument was placed on a tiered base of granite from Fairfield County. It was dedicated on June 20, 1883, and was initially erected at the intersection of Broad and Laurens Streets. The elaborate dedication ceremony began with a procession of 4 bands, 16 infantry companies, 3 Cavalry companies, 3 artillery corps, and a procession of about 700 men. The monument now stands in Monument Square.

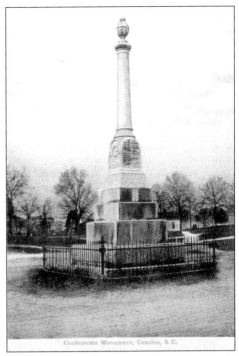

Confederate Monument, Camden, S. C.

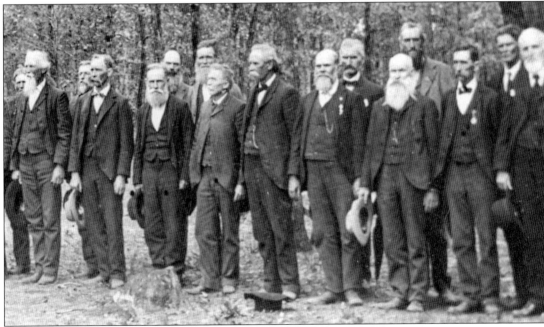

above, Lucas stands on the right side in the back row behind the third veteran. The commander-in-chief of the South Carolina Division of the United Confederate Veterans (Company F, 7th Infantry), E.N. Yarbrough (1843–1940), is the ninth veteran from the right side. The initial membership of Company A was 104 with 15 killed and casualties of 61, while Company F had a membership of 140 with a total of 16 killed and casualties of 91.

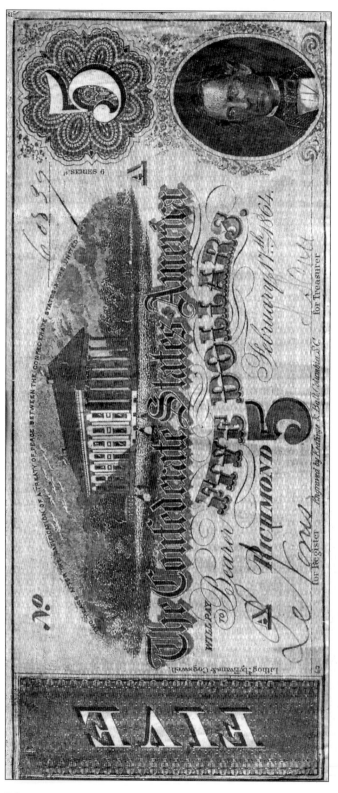

[CONFEDERATE FIVE DOLLAR BILL, 1864]. Most of the Confederate States of America's paper money was printed in Columbia at their plant on the corner of Gervais and Huger Streets. The 1864 engravings were made by Keating and Ball Engravers and the lithographers were Evans and Cogwell of Columbia and Charleston. The central image featured in the bill above is the Virginia State Capitol in Richmond, which was the capital of the Confederacy. The portrait in the lower right was of C.G. Memminger of Charleston, who was the first secretary of the treasurer for the Confederacy. This issue, found in the Camden Archives, was the currency used in Kershaw County and throughout the South during this era. Confederate bills and other items were often reproduced on postcards and mailed to collectors of Civil War memorabilia.

[GEN. JOHN D. KENNEDY, CSA, 1880].
Gen. John D. Kennedy (1840–1896) was
born in Camden and attended the South
Carolina College. He became captain of
Company E, which was a segment of the
Second Regiment. He served with Gen.
J.B. Kershaw and fought in the same
battles. At age 24, he was promoted to
commander of his brigade and became
the youngest brigadier general in the
army. In 1880, Kennedy was elected
lieutenant governor of South Carolina.
President Cleveland appointed him
consul general at Shanghai, China in
1884, a position he held until 1888.

THE CAVALRYMAN, [c. 1910]. The original
painting depicting the Confederate
cavalryman's typical uniform was created by
Civil War artist W.L. Sheppard and was
commissioned by the Confederate Museum in
Richmond, Virginia. Individual regiments from
the various Confederate states probably used
personalized variations of this uniform design.

35

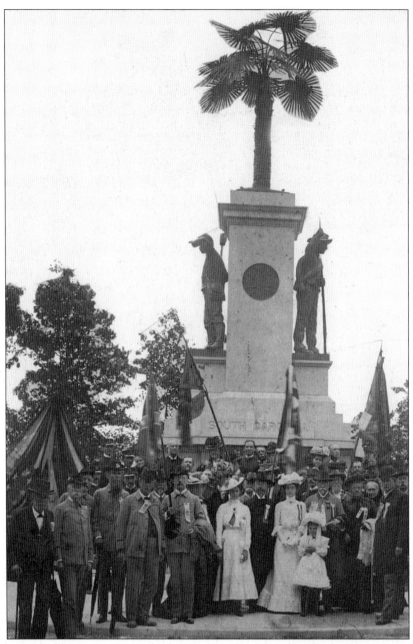

[Unveiling of the South Carolina Confederate Monument, 1901]. The South Carolina Confederate Monument on Snodgrass Hill, Georgia was dedicated on May 27, 1901. It commemorated the site of the September 19–20, 1863 Chickamauga Battle. Dignitaries included Gov. M.B. McSweeney, Gen. C. Irvin Walker, C.S.A., as well as many Confederate veterans. Col. Willie Jones, S.C. 2nd Regiment, led the procession that began with the 1st battalion, Company A, Kershaw Guards led by Captain S.C. Zemp. The monument was draped with Confederate colors before the unveiling. The 33-foot tall monument constructed of granite includes a life-size bronze sculpture of an artilleryman on the left of the main shaft and a bronze statue of an infantryman on the right. A ten-foot bronze palmetto adorns the top of the monument.

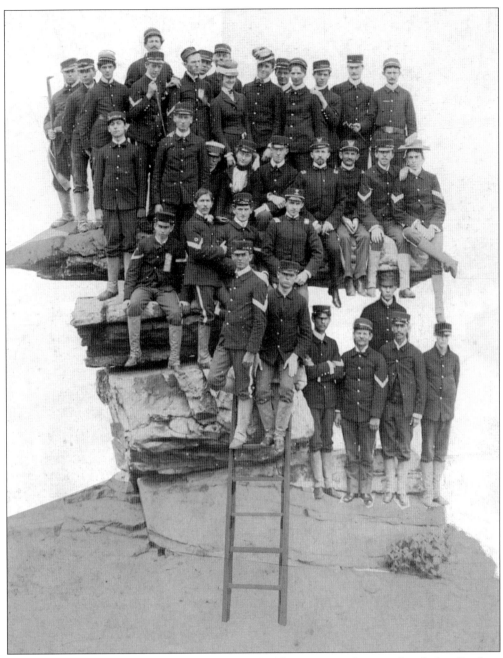

[KERSHAW GUARDS, LOOKOUT MOUNTAIN, 1901]. This group photograph of the Kershaw Guards was taken at Table Rock on Lookout Mountain after the men had participated in the dedication of the South Carolina Confederate Monument. The dedication was held on Snodgrass Hill in the Chickamauga National Military Park, which was designated a national park by an 1890 Act of Congress. The Kershaw Brigade played a significant role in the 1863 Snodgrass Hill battle and was invited to participate in the ceremonies. The Kershaw men left this park and toured other Civil War sites at Chattanooga, Missionary Ridge, and Lookout Mountain some 12 miles to the northwest.

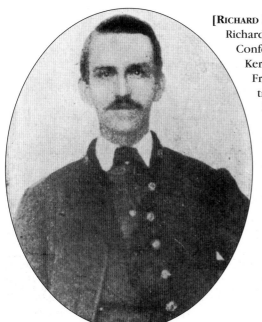

[RICHARD R. KIRKLAND, C. 1860]. This is a photograph of Richard R. Kirkland (1843–1863). He was a Confederate soldier who fought under Gen. J.B. Kershaw at Marye's Heights in the Battle of Fredericksburg, Virginia. Thousands of federal troops were killed that December 1862 day. No longer able to stand the pleas of the wounded Yankee soldiers crying for water, Kirkland carried water to them for an hour and a half. Both sides ceased firing as he helped hundreds of soldiers. Kirkland became known as "The Angel of Marye's Heights." He fought at Gettysburg and later fought and died at Chickamauga.

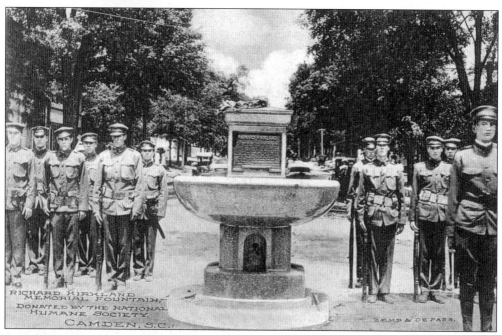

RICHARD KIRKLAND MEMORIAL FOUNTAIN [C. 1911]. The Kirkland Monument, a water fountain for man and beasts, was dedicated on May 10, 1911. It was partially funded by pennies collected by school children of Camden and Kershaw County and by the National Humane Alliance of New York, who designed the fountain and donated $1,000 towards its erection. The massive fountain made of brown marble was unveiled on May 10, 1911 at the intersection of Broad and DeKalb streets. A ceremony led by R.M. Kennedy included many veterans, dignitaries, and members of the Kershaw Guard. It was later moved to Hampton Park.

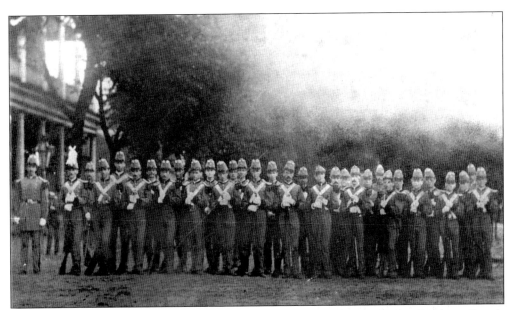

[**KERSHAW GUARDS, 1883**]. After the Reconstruction era (1865–1877), the Kershaw Guards (previously Company E) were reorganized in 1878 by Capt. E.B. Cantey. W.M. Shannon Jr. began leading the Kershaw Guards on July 4, 1883 and it became a part of the 1st Battalion, 4th Regiment Infantry. This 1883 photograph by W.S. Alexander includes Capt. W.M. Shannon, Sgt. E.J. Phelps, and Lt. E.M. Brunson for a total of 4 officers and 37 other militia volunteers. The 1883 Kershaw Guards used Remington rifles.

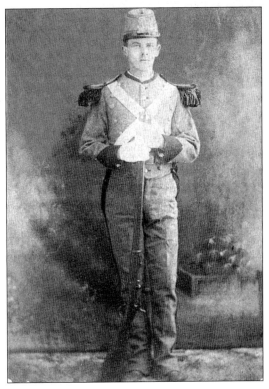

[**KERSHAW GUARDS' UNIFORM, c. 1884**]. The first Company M in the Colonial era was organized in 1775 as the Camden Militia, 2nd Infantry Continentals and was led by Capt. J. Martin. Company M was renamed the DeKalb Rifles in 1840 and evolved into Company C in the Mexican War's Palmetto Regiment led by Capt. K.S. Moffatt. The old Company C then merged into Company E, 2nd Regiment South Carolina Volunteers and was commanded by Gen. J. D. Kennedy. By 1916, Company M was in the 3rd Battalion, 1st Infantry, South Carolina National Guards that served in the Texas border conflicts. The image to the right shows the decorative fully dressed Kershaw Guards in 1884.

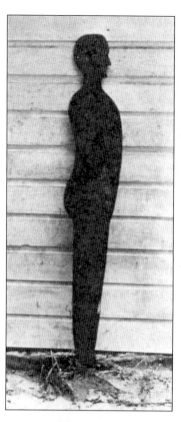

["IRON MAN," c. 1900]. The Camden area had boasted a history of dueling using the Code of Honor ever since the first recorded Camden duel in 1789. Col. James P. Dickinson is credited with having this full-scale iron human silhouette fashioned—in 1845—to practice for a pending duel. Neither Dickinson nor his challenger were injured in the duel. Years later, the Iron Man was found at the bottom of Factory Pond when the pond was drained for repairs to the dam.

[1ST SOUTH CAROLINA INFANTRY, 1916]. At the conclusion of the Mexican Border Conflict, El Paso, the 1st South Carolina Infantry, Company M 118 Infantry, South Carolina National Guard returned to Columbia. They are standing at attention on Main Street in Columbia on December 4, 1916. The officers in charge are (on horseback) Col. E.M. Blythe, Capt. G. H. Mahon, and 1st Lt. W.C. Wallace, 2nd Brigade with colors. Company M Kershaw Guards are standing next to the colors.

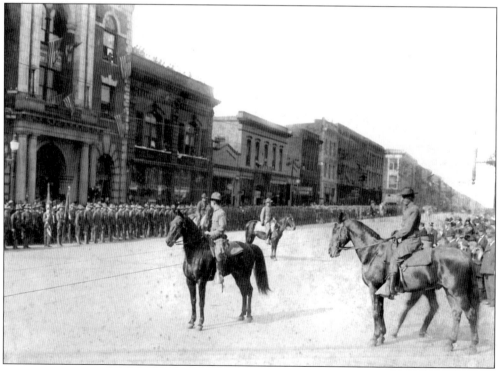

[COL. E.B.C. CASH, C. 1880]. Col. E.B.C. Cash (1822–1888), from Cash's Depot in Chesterfield County, formed a regiment for Confederate service, was elected colonel, and fought in the battle of the First Manassas. However, he was not reelected and returned home. Cash had a legal dispute with Col. W.M. Shannon that resulted in Cash killing Shannon in 1880. Cash was tried and acquitted for breach of the anti-dueling laws. The Cash-Shannon duel of 1880 caused the state to adopt an anti-dueling law.

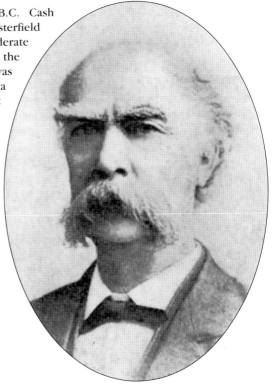

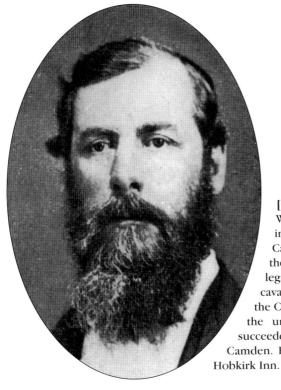

[COL. WILLIAM M. SHANNON, C. 1880]. Col. William M. Shannon (1822–1880) was born in Camden, graduated from the South Carolina College in 1841, was admitted to the bar in 1843, and was elected to the legislature from 1857 to 1862. He raised a cavalry company, the Kirkwood Rangers, for the Confederate Army and served as a colonel in the unit. Upon the death of his father, he succeeded to the presidency of the Bank of Camden. His home, "Pine Flat," was converted into Hobkirk Inn.

41

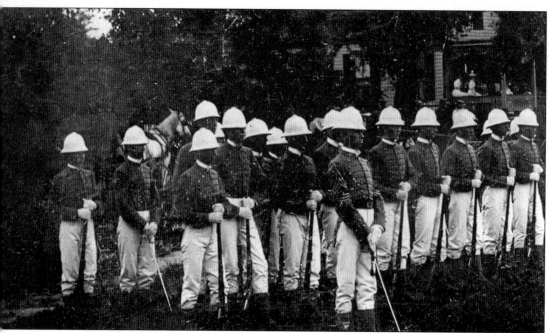

[S.C.M.A., CAMP KERSHAW, 1895.] This image, shown in two parts so readers may see all portions, depicts Company A of the 1895 Citadel Corps of Cadets. As early as 1883, the Board of Visitors of the South Carolina Military Academy, The Citadel, considered the idea of holding off-campus summer encampments of the Corps of Cadets that could advertise the reopening of the academy. The 1895 battalion of academy cadets of the South Carolina Military Academy began with a train trip to Columbia for the Annual Military Session. This was followed by a 3-day, 36-mile march to

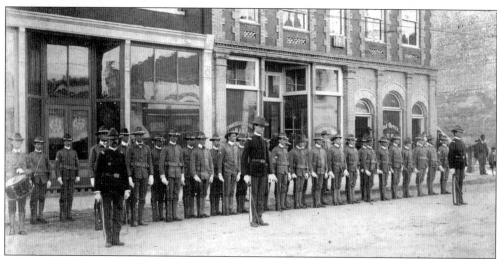

[KERSHAW GUARDS, 1915]. I.C. Hough was the captain of the Kershaw Guards in 1915. Their duties were to keep the peace during local unrest. Company K 1st Infantry was called out on June 14, 1915 to Winnsboro after an angry crowd shot and killed J. Smith, Sheriff A. D. Hood, police officer R. Bowlware, and C. Eisenhower on the courthouse steps. The militia kept the courthouse grounds under arms until nightfall. Kershaw Guards were also sent to the town of Kershaw in 1915 to restore order.

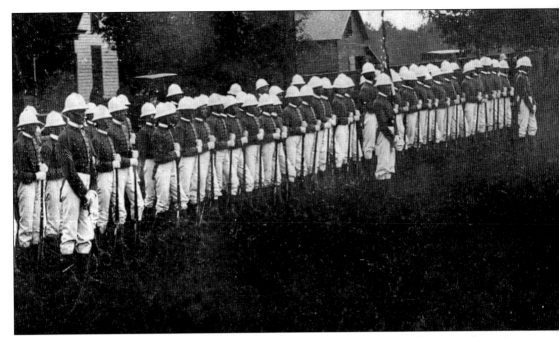

Camden to encamp at Camp Kershaw. The cadets, wearing their summer uniforms, performed the usual camp duties, along with the Company Competitive Drill. The drill was won by Company A. The Individual Drill for the Star of the West Metal was won by Corp. J.D. Dial. The June 30 graduation ceremonies were held at the Kershaw County Courthouse with L.F. Youmans of Columbia as the commencement speaker.

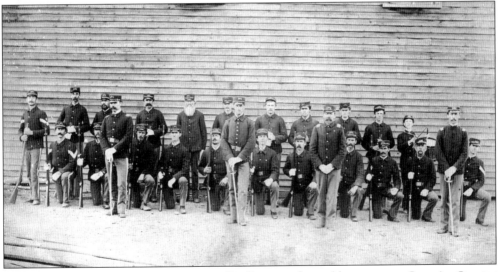

[CANTEY HILL RIFLES, 1901]. The Cantey Hill Rifles were formed by men near Grannies Quarter Creek north of Camden. Capt. C.P. Lorick led Company K of the 1st Regiment of the South Carolina Volunteer Infantry from 1895 to 1900 with 32 enlisted men that were issued carbine rifles. The picture above shows the 1901 company beside Watts store and post office, where they held regular meetings. Their commander was Robert L. Smyrl, standing in front, second from the right.

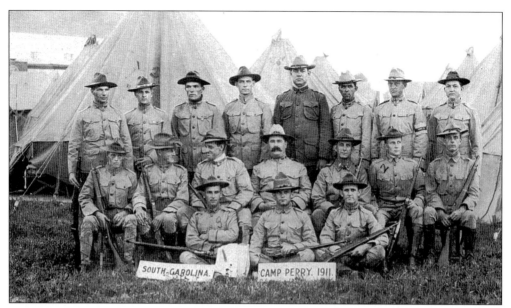

[SOUTH CAROLINA, CAMP PERRY, 1911]. In 1911, the three South Carolina National Guard Infantry Regiments contained 187 officers and 1,719 enlisted men. A South Carolina rifle team, seen above, was selected to compete in the National Shooting Competition held from August 14 to September 1, 1911 at Camp Perry, Ohio. South Carolina Brig. Gen. W.W. Moore led the team of 12 contestants and 4 alternates with G.W. Johnson, coach.

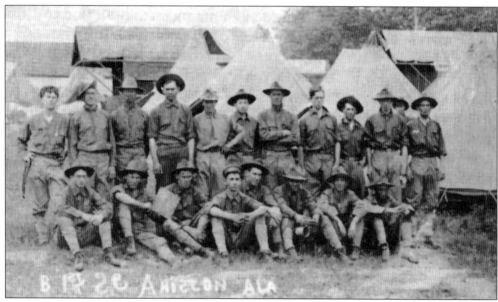

[LIBERTY HILL RIFLES, 1910]. After the Reconstruction Era, young men who could afford the expense of uniforms joined militia. An annual inspection by the South Carolina adjutant general and federal army officers were often held at Fourth of July picnics. The Liberty Hill Rifles, Company B 1st S.C. Regiment, was organized by Capt. J.G. Richards Jr. of Liberty Hill. The regiment commander at the final encampment at Anniston, Alabama in August 1910 was 2nd Capt. N.S. Richards. The group disbanded after 1910.

Three
TRANSPORTATION

The first pioneers traveled by wagon along poor rutted paths that passed the few river ferries that existed. The Wateree and Santee River system permitted slow flatboat trips to and from Kershaw County. Announcements for stagecoach routes were published in 1825. Daily railroad travel began with the South Carolina Railroad Company's Charleston to Columbia 130-mile line and a spur track to Camden in 1848. Other railroad lines were built in 1887, 1899, and 1900, which gave east-west and north-south routes to regional and national markets. By 1910, automobile travel began to expand beyond the towns and convict labor was used to repair washed out dirt roads. Finally, the first airport in Kershaw County was dedicated in 1929.

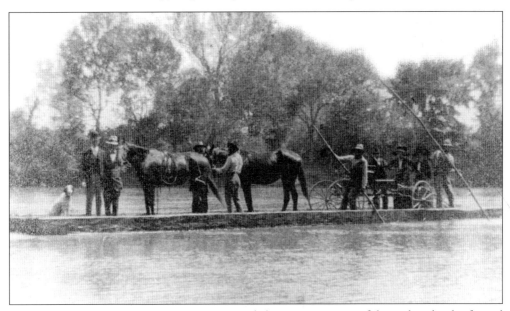

[**PEAY'S FERRY, RIVER TRANSPORTATION, 1911**]. Pole barges were some of the earliest kinds of travel on the Wateree and Santee Rivers. In 1786, S. Mathis ran boats from Camden to J. Mouzon's store at the mouth of the Santee River, where schooners carried the cargo to Charleston. Rafts from Chesnut's Ferry and Peay's Ferry also sent goods down river. Some boats used the Santee Canal in 1798 for a shorter trip to Charleston. In 1828, Camden sold 12,900 bales of cotton with 33 riverboats arriving on one day to transport cotton and goods down river. Steamboat travel between Camden and Charleston carried passengers and cotton in the 1830s. Peay's Ferry, shown above, was a major ferry crossing the Wateree River between Liberty Hill and Cassels in Fairfield County and was used for 150 years. The 1919 Wateree Lake covered this ferry site.

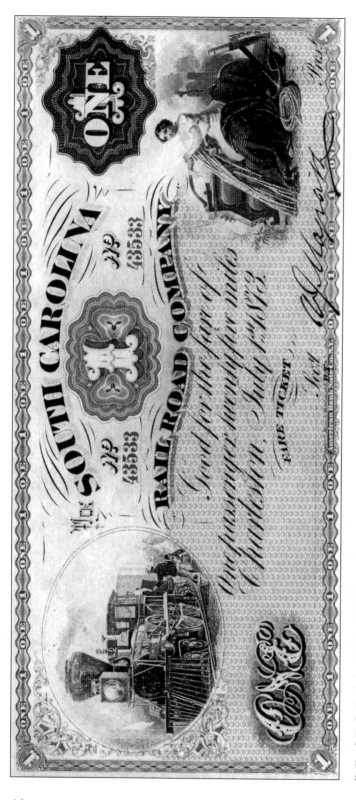

[ONE DOLLAR BILL, SOUTH CAROLINA RAILROAD COMPANY, 1873]. Passengers using the original South Carolina Railroad Company line in 1845 left the train at Gadsden and took an eight-hour stage coach trip, run by J. McEwen, to travel to Camden. In 1848, the first branch rail line to Camden from the old South Carolina Railroad that connected Columbia to Charleston, began at Kingsville and used a four-mile trestle over the Wateree River and swamp to the Manchester depot. Before then, local merchants hauled goods to be shipped by rail to the Manchester depot 28 miles away. South Carolina's shattered economy and limited industrial base restricted passenger use to businessmen and the wealthy. Shipments of freight were the major source of income, which meant that many rail lines were constantly close to insolvency. In 1873, the South Carolina Railroad Company began to issue company paper money to the public, which, like state and federal paper scrip, could be used to purchase merchandise or pay bills. The exchange of paper money gave the railroad another source of income.

[SOUTHERN PASSENGER DEPOT, CAMDEN c. 1907]. The first trips on November 1, 1848 out of Camden on the South Carolina Railroad Company trains left Camden at 6 a.m. They traveled the 32 miles to the junction at Kingsville, arriving at 8:15 a.m. A return trip left the junction at 2:45 p.m. and arrived in Camden at 5:15 p.m. The fare to Columbia was $3. On January 31, 1849, almost 2,000 packages of goods arrived at Camden by train in one day. Over 30,000 bales of cotton had been shipped by rail in the first 3-month period. In 1902, the Southern Railway Company obtained this spur and other insolvent rail lines in North and South Carolina. The picture above shows the original Southern Railway depot in Camden. Their passenger station was on East DeKalb Street.

[OLD SEABOARD DEPOT, CAMDEN, c. 1920s]. The Seaboard Airline Railway created a second rail system that would connect the northeastern economic centers with Florida. In 1899, their line passed through Hamlet, North Carolina through Cheraw, Columbia, Savannah, and other points south. Kershaw County depots were at Bethune, Camden, Lugoff, and Blaney [Elgin]. The early steam locomotives used wood for fuel and needed numerous stops and depots—every six miles—for wood and water. These depots created important economic communities in the rural areas. Hotels, banks, warehouses, stores, schools, and churches were established by the depots during the first half of the 20th century. The Camden Seaboard Passenger station was at Gordon and Chesnut Streets and the freight station was at Gordon and DeKalb Streets.

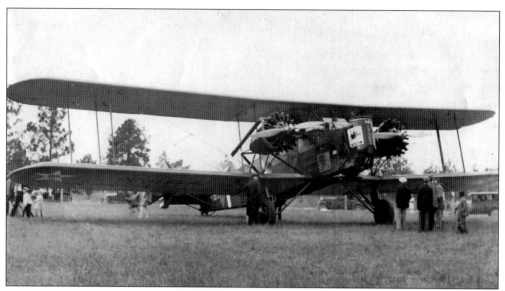

[FIRST AIRPLANE FLIGHTS, DEDICATION OF CAMDEN'S AIRPORT, 1929]. Over six biplanes from Charlotte were flown down to Camden for the 1929 grand opening of the Camden airport. Visitors were invited to take brief airplane flights over Camden for a small fee. Kirkwood Hotel's photographer E.T. Start took the photographs.

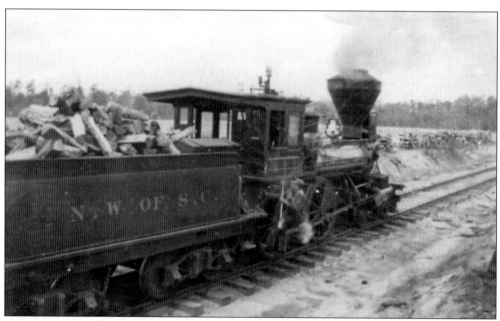

[NORTHWESTERN RAILWAY OF SOUTH CAROLINA LOCOMOTIVE, 1903]. The Northwestern Railway was built by Col. Thomas Wilson in 1900 to connect Camden to Sumter and was often called the "Wilson Short Cut." The 1903 view above shows one of their locomotives stopped on the tracks. This may have been a wood and water stop since the tender car behind the locomotive is piled high with firewood. After the wood was picked up, the engineer was photographed climbing back into the cab to continue his trip. This line was later obtained by the Atlantic Coast Line, which was the third regional rail system in South Carolina.

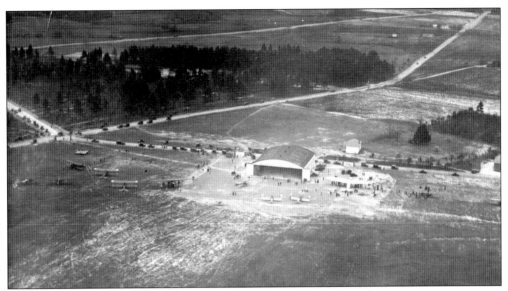

[**AERIAL VIEW OF WOODWARD FIELD, 1929**]. Ernest L. Woodward contributed land for the airport in August 1928. The Woodward Field Airport was established in 1929 at a cost of $30,000. The aerial view of the airport hanger and grass landing strips shows many visitor automobiles parked along the roads as they inspect the airport and wait for rides on the planes. The Woodward Field Airport is northeast of Camden between the Jefferson Davis Highway [US#1] and Red Fox Road.

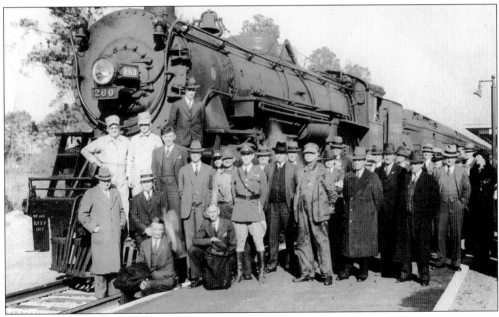

[**FIRST TRAIN USING THE NEW SEABOARD DEPOT, C. 1937**]. This November 18, 1937 picture shows the opening day ceremony of the new Seaboard Railway station. Train #191 paused at the old depot so the city officials and community leaders, such as Robert M. Kennedy Jr., chairman of the depot committee, could board the train and become the honorary train crew. Mayor J.H. Osborne, wearing the overalls of a Seaboard engineer, gave the welcoming speech to the crowd standing in front of Locomotive #260. The new depot cost $50,000.

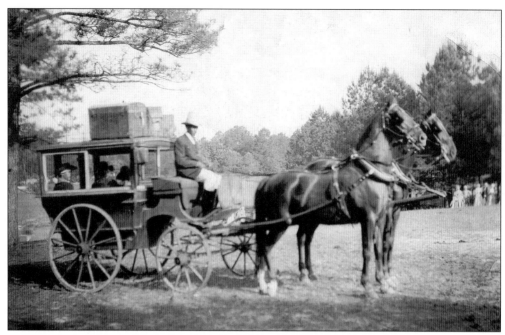

[STAGECOACH TRAVEL, 1925]. Stagecoach travel was usually a long, slow, uncomfortable trip over poor roads, fording many streams, and taking ferries across the several rivers. In 1824, Mr. McLane organized a Camden-Charleston stage line that he advertised could make the trip in two days. Later the Charlotte and Camden Stage announced a one-way fare of .625¢ per mile and 5¢ per mile round trip. The view above shows a coach that was used in the 1925 reenactment of George Washington's visit to Camden.

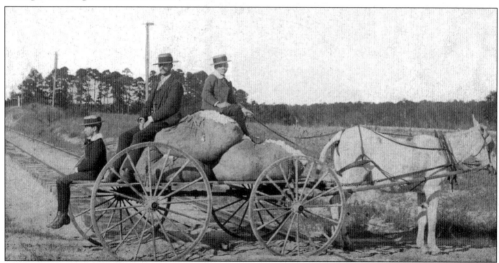

[CARRYING COTTON TO MARKET, C. 1900]. This is an early view of a farmer traveling to the cotton gin. His two boys, dressed in their best suits, shoes, and hats take one of their few trips to the nearby community. The proceeds from his sale must pay off his accumulated debt at the mercantile store that advanced the costs of seeds, fertilizer, and supplies at planting time. The debt had to be paid at harvest time along with debts at the bank and other merchants. This annual income must also cover farm improvements and family expenses until the next harvest.

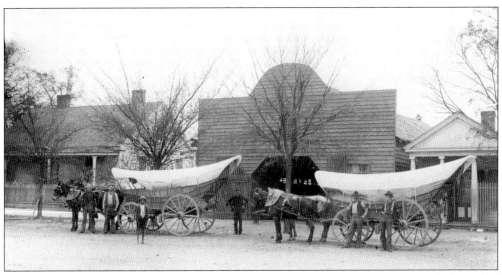

[BLIND TIGER WAGONS, c. 1900s]. The Conestoga wagon, made by the Moravian craftsmen of Bethlehem, Pennsylvania, was used by German and English settlers in the early 18th century and became a major freight wagon. Some of those craftsmen moved south to the Moravian village of Salem, North Carolina and began building these wagons. Tycho Nissen's shop (1770) in Salem made similar two-horse wagons that were used for tobacco farming. G.E. Nissen's 1883 advertisement listed these wagons from $70 to $85. In Camden, the term "blind tiger" applied to bootleg liquor dealers during the days of the South Carolina Dispensary. It was suggested that the owners of some of these wagons hauled illegal bootleg whiskey.

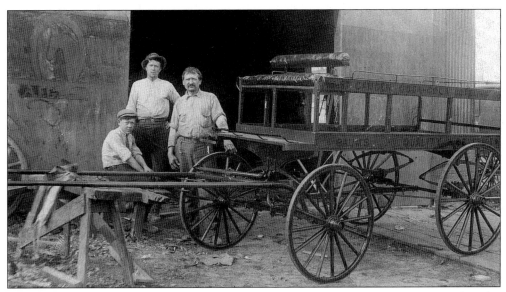

[GRADICK'S BLACKSMITH SHOP, 1911]. In July 1911, J.L. Gradick opened a wheelwright, blacksmith, carriage, and general repair shop opposite Little's stables. He placed a large advertisement in the July 28, 1911 issue of the *Camden Chronicle*. The building stood where the County Agricultural building now stands on DeKalb Street (U.S. #1). The carriage above was being built for the Coca-Cola Company. Gradick (right), W. Gaskins (center), his son-in-law, and his son are shown in this picture.

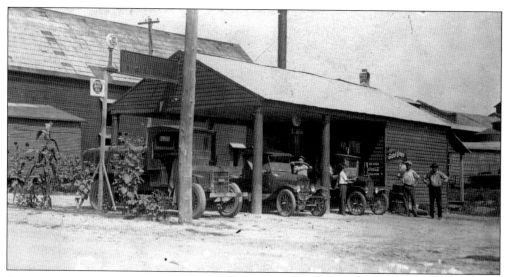

[EAST DEKALB STREET GAS STATION, 1930s]. When the automobile became a major means of personal transportation, gas stations became both necessary and convenient sites before and during trips away from town. East Dekalb Street Gas Station, Marion's Service Station, City Filling Station, and Jim Watts Station were some of the many gas stations on U.S. Highway #1. Some stations were open all night to repair autos or sell oil, batteries, tires, and accessories.

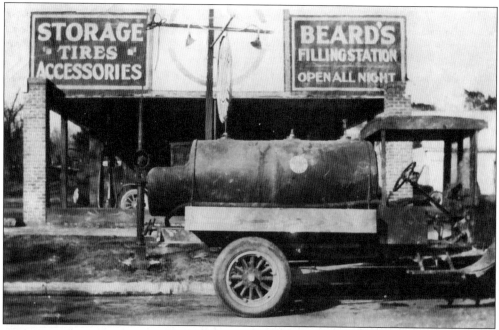

[BEARD'S GASOLINE TRUCKS, C. 1930s]. Henry E. Beard Sr. established the Beard Oil Company in 1920. The first deliveries of fuel were shipped in 55-gallon barrels from Baton Rouge, Louisiana, and was sold in conjunction with Beard's bicycle shop. The fuel was generic until 1928, when his company went with Standard Oil Company. His first transportation was a 1918 Model T Ford with an old horse-drawn tank on the back. Later, H.E. Beard and J. Laney launched the Beard-Laney Tank Lines to deliver fuel.

Four
LOWER KERSHAW COUNTY

At the end of the Civil War, the rural land holdings of Kershaw County were divided into three groups. The first group was large tracts of land, like the Mulberry Plantation. The second was smaller farms, where the owners were able to make a profit and pay their taxes. The third was the unfortunate group who lost their property because of poor crops, low cotton prices, and high taxes. Farm labor was usually performed by displaced farmers and freedman, both of whom drifted from place to place as tenant farmers and workers on the lands of others. Fortunate planters enjoyed their great houses, socials, sports, hunting, and the good life. Several of the entrepreneurial farmers established saw and gristmills and cotton gins to process their own harvests and that of their neighbors. Cotton was king at the beginning of the 20th century with timber replacing it as a revenue source after the boll weevils damaged the cotton crops. The lack of a good rural educational system handicapped the small farmers and tenant workers in their struggle to improve their lives while the successful farmers sent their children to boarding schools and colleges. The images in the rural chapters document the schools, churches, industries, and lifestyles of the successful but seldom show the daily life circumstances of the masses.

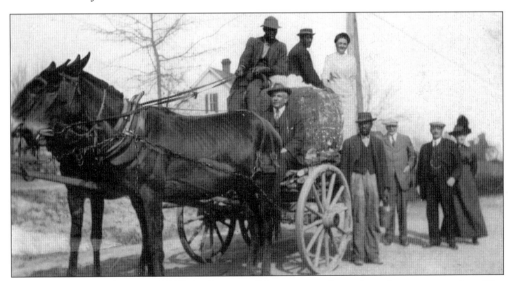

[COTTON WAGON AT FARM, C. 1910]. At the turn of the century, the main cash crop was cotton. The sight of farmers' wagons coming to the gins with bags of cotton was common during the harvest season. This production continued until the boll weevil infested the cotton crops across the region and nation causing farmers, merchants, and bankers to face bankruptcy and lose their farms and businesses.

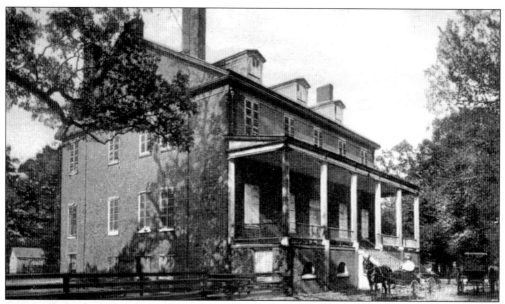

[MULBERRY PLANTATION, c. 1907]. Mulberry Plantation, south of Camden, was completed in 1820 by Col. James Chesnut (1773–1866). The house has a simple, unadorned, federal-style exterior. It was built by David Bartling, a master builder from Philadelphia, who had worked with the famous architects Robert Mills and William Strickland. Mulberry has a slate roof, steps of marble, and a broad front porch with Doric columns. Bricks were made in the kilns on the plantation. In Colonel Chesnut's day, the plantation covered five square miles. In summer months, the family moved to their Sandy Hill Plantation on higher ground to avoid malaria. Colonel Chesnut served in the state legislature from 1802 to 1808, as Camden's mayor from 1806 to 1807, and as a state senator from 1832 to 1836.

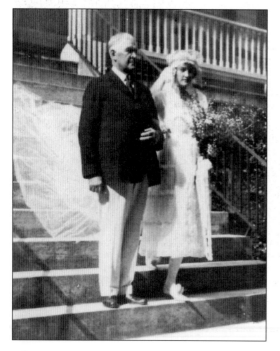

[WEDDING AT MULBERRY, 1920]. The Chesnut family, originally Scotch-Irish, lived in Virginia before traveling south to settle in the Camden area in the late 1750s. Col. John Chesnut (1743–1818) and his brother first acquired Mulberry lands from the earliest Quaker settlers. Many weddings took place at Mulberry, however, the May 1920 wedding on the 100th anniversary of the completion of the house, was a special occasion. The picture above shows the father and bride standing on the steps. The marriage ceremony of Bland Williams and Capt. W.A. "Reddy" Metts was held on the front lawn. A lamb and pork barbecue was prepared for the guests and the descendants of former Mulberry slaves gave an afternoon of song for the occasion.

[GEN. AND MRS. JAMES CHESNUT JR., *c.* 1840]. Gen. James Chesnut Jr. (1815–1885) resigned his senate seat in 1860 and served the Confederacy as an aide to President Jefferson Davis. His wife, Mary Boykin Miller Chesnut (1823–1886), is known for the journals she kept during the Civil War. The journals became a primary source for leading historians. They were also used by journalist Ken Burns for his award-winning PBS Series *The Civil War*. In recognition of her work, Mulberry Plantation was made a national historic landmark in 2001.

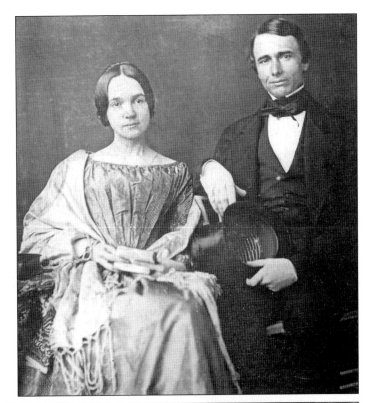

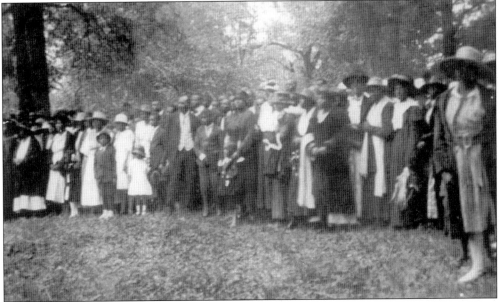

[MULBERRY WORKERS AT THE WEDDING, 1920]. On the 100th anniversary of the completion of the house, descendants of slaves came on foot, astride mules, or in wagons to attend the wedding. When the wedding party assembled on the lawn they sang "Sweet and Low" and other hymns. The small boy in the front row is Leroy Fraiser, whose grandfather, Peter Aaron, led a group of Mulberry workers to put out the fires set by Sherman's forces in an attempt to destroy the house.

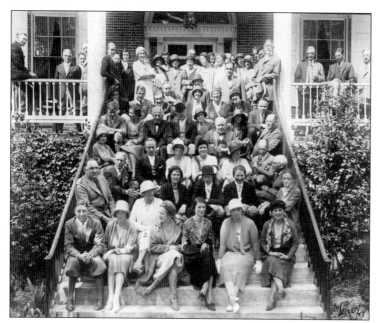

[HUNT BREAKFAST AT MULBERRY, c. 1930s]. Fox hunting began in the colonial era. The Camden Hunt was founded in 1926 and had about 115 members. Hounds were assembled on Wednesdays and Saturdays at 9 a.m. On this occasion, hunt members and guests assembled at Mulberry Plantation for a breakfast after the hunt. The formal hunting season began after Thanksgiving and lasted into mid-March.

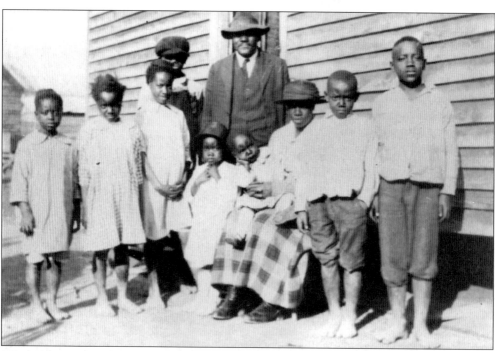

[PLANTATION FAMILY, MULBERRY, c. 1920s]. This family picture is of Pierce and Sarah Stanley Stradford and eight of their ten children who lived on the plantation. Stradford was a distinguished deacon in his church, the Wesley Chapel, on Mulberry Plantation. They lived in a section of frame cabins built in a clapboard style construction, placed on small pillars to elevate them from the ground. In colonial times, these cabins were often log structures. Brick cabins were also provided on Mulberry. The cabins were often in rows, on either side of a road, in the manner of a small village.

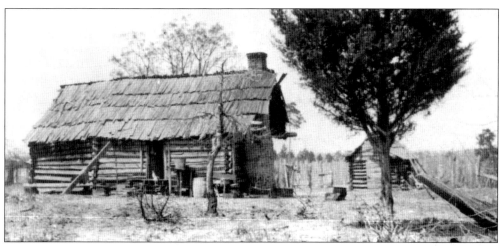

[PLANTATION CABIN, MULBERRY, C. 1920s]. Plantation farming began in the colonial days when large land holdings permitted the cultivation of indigo, cotton, rice, sugar cane, and corn. Slaves were needed to grow these crops and small cabins were built to house them. The log cabin above has a hand-cut shake roof and may have been a slave or tenant house that existed on the plantation during the 19th century.

[FRANK SUTTON, DRAG MAN, C. 1920s]. The Camden Hunt was a drag hunt. Early in the morning, the scent of a fox, in a cloth bag, was dragged through the country. Hounds would follow the scent, often for 20 miles to complete the route as laid out by the drag man.

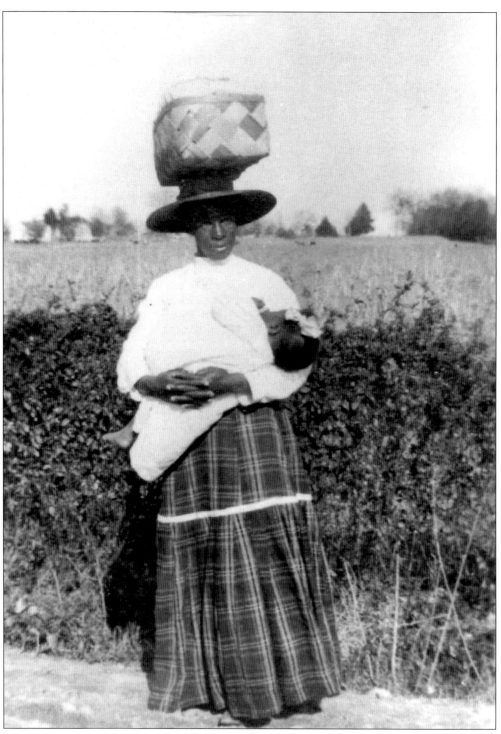

[WASHERWOMAN AND CHILD, c. 1920s]. This image is of a washerwoman carrying laundry in a basket on her head, which allowed her to hold the nursing baby in her arms. Clothes were washed in large, iron cauldrons, over a fire to heat the soapy water.

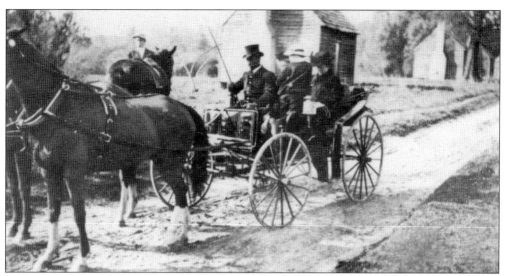

[VISITORS AT MULBERRY, C. 1907]. Col. John Chesnut began to establish Mulberry as a series of small indigo plantations in the 1760s. Chesnut expanded the plantation and converted most of the land to short, staple cotton production during the height of the cotton economy in 1800–1820. Col. James Chesnut and Gov. David R. Williams of Society Hill became partners to construct cotton mills in the South. The image above shows a tour of Mulberry Plantation by the Bolton family of Cleveland, Ohio. Several plantation cabins are seen in the background.

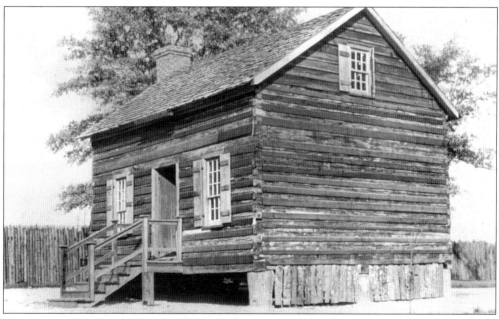

[DRAKEFORD HOUSE, C. 1990s]. The Drakeford House was located on a dirt road east of KC #597, about 12 miles northwest of Camden near Grannies Quarter Creek in the Flat Rock community. The initial 285 acres was granted to Lewis Cook in 1806 and included the home site. The 100 acres sold to Richard Drakeford in 1812 contained this site. It is presumed that Drakeford built this early log residence, which is typical of early 19th-century log homes in that area. This early residence was dismantled and reassembled at Historic Camden Revolutionary War Site.

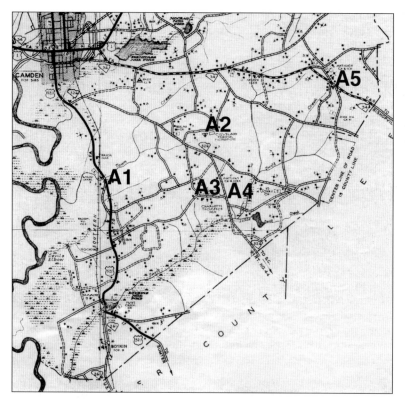

[MAP OF LOWER KERSHAW COUNTY, 1939]. This section of a Kershaw county highway map shows the southern area from Camden to the Boykin.

[WESLEY CHAPEL, A-1, *c*. 1920]. The site of the African-American Wesley Chapel was listed in the estate of James Chesnut, 1866, and was called the Wateree Mission Chapel. Mary Boykin Miller Chesnut wrote about the chapel and mentions Rev. M. Brown. Later, the building was also used as a school during the week. In April 1866, the congregation joined the South Carolina Mission Conference of the Methodist Episcopal Church, Camden circuit, which included Trinity, Good Hope, and Wesley Chapels, which remained together until 1874. Rev. W.C. Deas and officers of the church built the present building in 1880s. The Mather Academy for black children sent missionaries to the church and school *c*. 1910. In 1913, this Cleveland School District #2 public school had 1 teacher, 5 grades, and 125 students in an 80-day term.

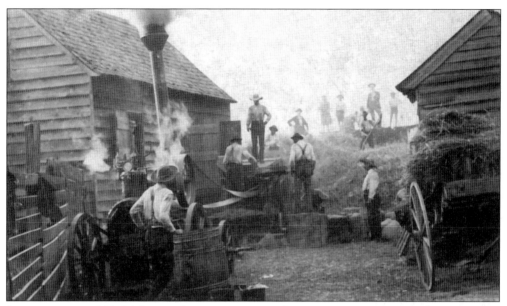

[FARM WORK, C. 1920s]. This Kershaw County scene shows a steam generator with large pulleys to run long belts to cut, grind, or mix raw material and create a finished product. Steam engines were used to cut and dress lumber, to run cotton gins and gristmills.

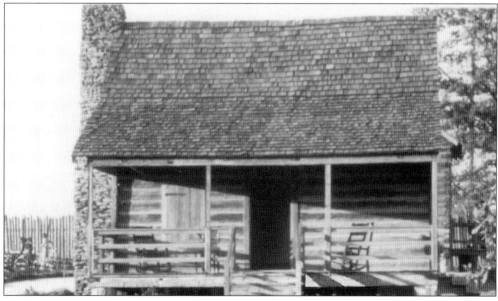

[BRADLEY HOUSE, C. 1970s]. The site where the Bradley House first stood was part of a 150-acre grant, in 1775, to John Bradley. It was by Harvard's Branch in an area now called Scape O're Swamp. The house was built c. 1800. Both the one-room house with the loft and the disassembled chimney (made of layers of flat sandstone) were moved to the Historic Camden Revolutionary War Site where the house, porch, roof, and chimney were reassembled. The walls were made of squared hand-hewn pine logs and were dovetailed at the corners. The log floor joists are half round logs cut to fit over the sills. The floors are pine boards 12 inches wide. A staircase was used to get to the loft.

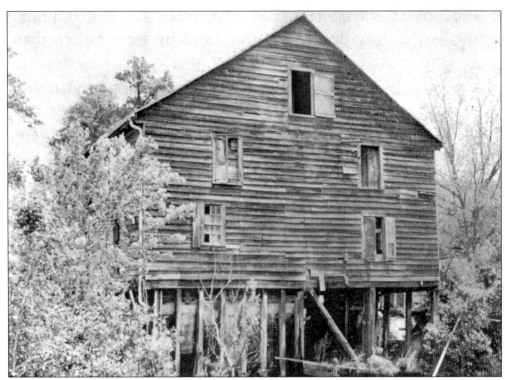

[BOYKIN MILL, c. 1930]. This community was founded in 1792 and Boykin Mill was erected shortly thereafter. An earthen dam was built across the small swamp halting the flow of Swift Creek and impounding water that created a 400-acre pond. The flow of water through a turbine at the end of a short canal, located near the head of the dam, could generate 30 to 50 horsepower to drive a grist or a saw mill. Farmers also had their cotton ginned, their sugarcane made into molasses, and their trees sawed into lumber. The present two-and-a-half-story frame weather board mill was built in 1905. The building still stands in 2002 and continues to grind grits.

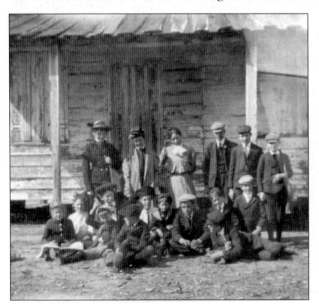

[ONE-ROOM FRAME SCHOOLHOUSE, c. 1910]. When children had to walk more than three miles to a distant rural school, families often asked a local farmer to allow them to build a school on his land. Most early rural schoolhouses were drafty, poorly-lit shacks that may have originated as tenant buildings. Teachers usually boarded with a local family and had to walk to school. The picture here came from a Boykin source but the site has not been identified. In 1913, the Line Academy—on the Sumter County Line—was a one-room school.

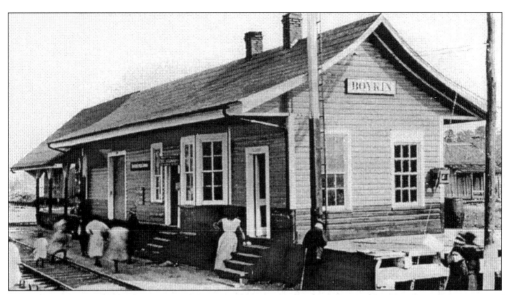

[BOYKIN DEPOT *c.* 1917]. Around 1820, Boykin was a community south of Camden near the Sumter County line. Boykin Mill was historically known as Mill Tract Plantation and was owned by Burwell Boykin (1752–1817). A.H. Boykin (1815–1866) was a prominent planter, a state legislator from 1846 to 1859 , and, later, a state senator from 1859 to 1864. He was also a director of the South Carolina Railroad Company. The Boykin Depot was established in 1848 as a fuel stop on the branch line from Kingsville to Camden on the South Carolina Railroad line. A new post office, called Boykin's Depot, was established in 1849. The railroad line was taken over by the Southern Railway Company in 1902. The population in 1910 was 100.

[OLD SWIFT CREEK BAPTIST CHURCH, BOYKIN *c.* 1930]. The Swift Creek Baptist Church was organized in 1783 and was a branch of the High Hills Baptist Congregation. Lewis Collins was the pastor in 1804 when another structure was raised further up Swift Creek. The present edifice was built *c.* 1827 when the congregation had 55 members. This frame sanctuary had galleries for slaves on both sides of the interior walls that were entered by stairs at the back of the church. A.H. Boykin, his wife, and his family were active in the church before the Civil War. The sanctuary is in a beautiful, restored condition in 2002.

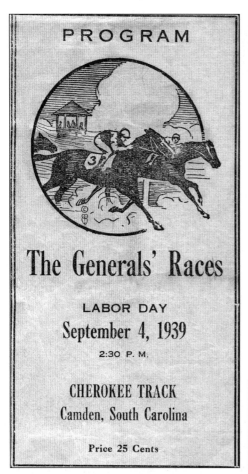

PROGRAM

The Generals' Races

LABOR DAY
September 4, 1939
2:30 P. M.

CHEROKEE TRACK
Camden, South Carolina

Price 25 Cents

[THE GENERALS' RACES, 1939]. The Races at Boykin were called the Generals' Races and each race was named for one of the six Confederate generals from Kershaw County. The Cherokee Track's fall races used judges J. W.Cantey, Dr. T.B. Bruce (a noted veterinarian), and C.P. DuBose Jr. from the Springfield Race Course. In the early 1940s, there were many military officials and dignitaries in Kershaw County. In 1941, Gen. George Patton visited several races. After the afternoon races, Mr. and Mrs. Bolivar D. Boykin entertained guests with receptions in their home, Millway, across the road from the racetrack.

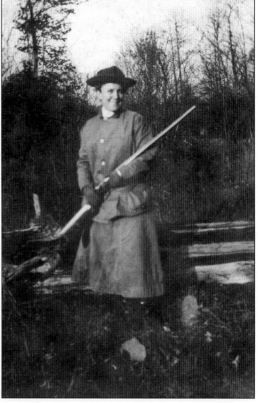

[META BOYKIN HUNTING, 1930s]. Meta C. Boykin (1888–1948), wife of Bolivar D. Boykin (1888–1946, was born at Pine Grove in the Boykin area. Meta was a great markswoman, who was considered the best shot at hunting turkey. They lived at Millway and were known in their community as generous and gracious hosts. Northerners found that Boykin was an excellent hunting area for deer, ducks, and doves. The Boykin Hunting Club was organized in the 1948 with 14 charter members. The purpose was to preserve the remaining game of the area and to have a place where the next generation would learn the sportsmanship of hunting.

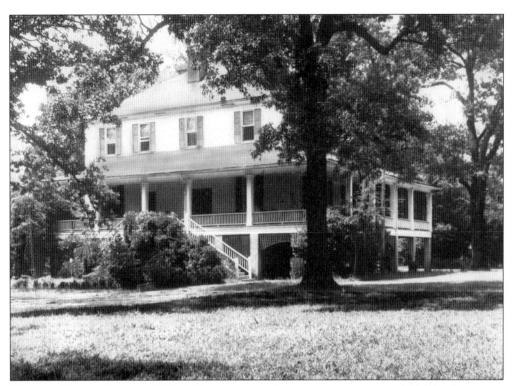

[MILLWAY, BOYKIN HOME, c. 1930s]. The original one-story house, c. 1850, had two rooms above the first-floor basement. After the Civil War, Alexander H. Boykin Jr. enlarged this house. He expanded the main floor and added a rear section of rooms, along with an additional second-story floor. Later, a porch with columns was added on three sides of the home. In the 20th century, portions of the back porch were enclosed with an additional kitchen wing. Millway is near Swift Creek Church, Boykin Mill Pond, and the Boykin Mill.

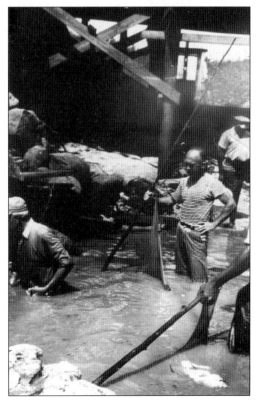

[SEINE FISHING AT THE MILL POND, c. 1920]. Fishing was a popular recreational activity and each individual had favorite fishing sites. Boykin Mill Pond accumulated a larger volume of fish and this view shows that seining nets were being used to capture the fish. Big ones were kept and small ones were thrown back.

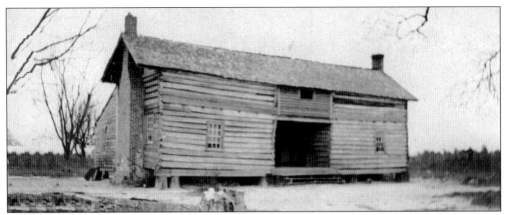

[BLOCKHOUSE, C. 1907]. In the 1890s, the blockhouse was the first structure erected on the farm. The picture above illustrates the evolution of the blockhouse. The farmer felled the trees to build a simple one-room blockhouse with roof and chimney. As that family grew or prospered, a second block room with a chimney was constructed with a breezeway in between and a loft above. Later, an addition was built in the back. Water was carried from the nearest creek or spring.

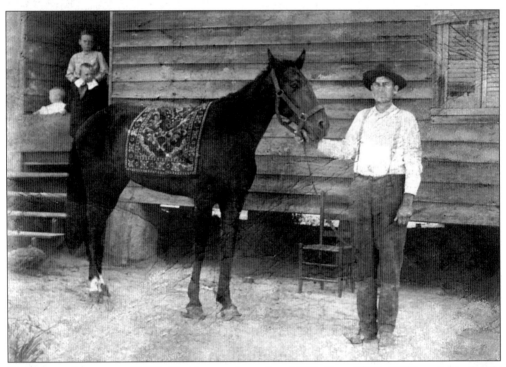

[J.W. CATO FAMILY, C. 1910]. The image above is of J.W. Cato (1871–1929) and his family standing in front of a tenant house. The tenant farmer was one of the major segments in the rural work force. Many families lost their homes and land after the Civil War and then shifted from site to site trying to make a living. Landowners needed farm help so these workers lived in simple cabins on the farms and worked for a percentage of the crop sales. Often, the family's children would have only one change of clothes, which were made from the printed-cloth flour sacks. Since the family mule plowed and hauled farm supplies and harvests, it was often the most valuable possession of the farmer and was therefore included in the family portrait.

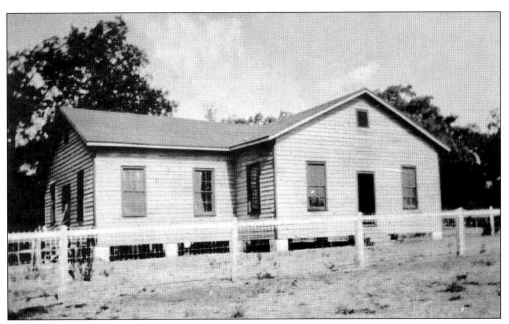

[BEAVERDAM BAPTIST CHURCH, C. 1910]. The Beaverdam Baptist Church was organized in 1859. The pastor was Rev. J.E. Rogers and the delegates in 1880 were T. Elliot, J.R. Thorn, and J. Munn. The congregation had 65 members. In 2002, it is located on Tidwell Town Road (KC #505) near Old Georgetown Road.

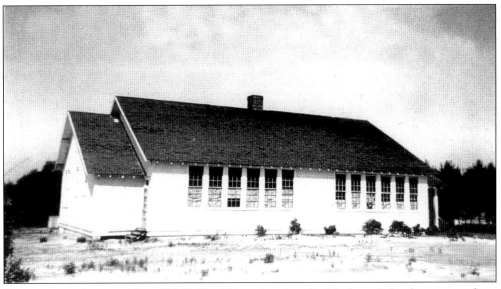

[ST. MATTHEWS SCHOOL, A4, C. 1930]. The African-American St. Matthews School was across from St. Matthews Church. The 1900 school District #2 had three black schools including St. Matthews, A4 (Boykin and Wesley Chapel, A1), which housed 276 children in a 60-day school session. In 1913, the St. Matthews 1-room, 5-grade school had 114 students for an 80-day term. The teacher made $110. At that time, school attendance was not mandatory and some farmers felt work on the farm was more important. The family could keep the child home for any reason. The two-room structure above was in a modern style.

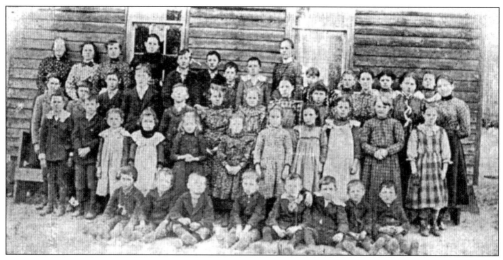

[CLASS PICTURE AT PINE TREE SCHOOL, 1900]. Pine Tree School was located 10 miles east of Camden on the Stagecoach Road near Pine Tree Presbyterian Church. This class picture was taken when it was a 1-room, 1-teacher school with 44 students in school district #4, which had a 28-day term. Teacher A. Holland lived in Cassatt. By 1913, Pine Tree had evolved into a 2-room and 2-teacher unit with 66 students using an 8-grade curriculum and an extended 120-day session.

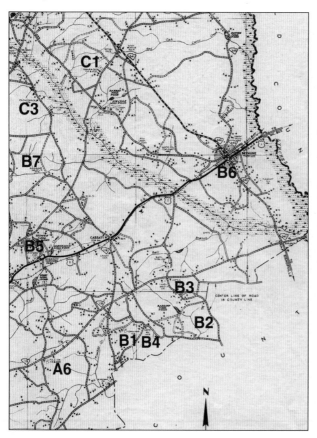

[MAP, EAST CENTRAL KERSHAW COUNTY, 1939]. This section of a Kershaw County highway map shows the location of the public schools in this area. Each school site has a code, which is included in the caption of that school. This map includes Bethune and the lower eastern boundary line on either side of the Little Lynches River. Other maps are found on pages 60, 82, 91, 98, and 110. Caption road symbols are US# (federal), SC# (state), and KC# (county). Road names for 2002 are used in the text. Community population data comes from the 1910 census.

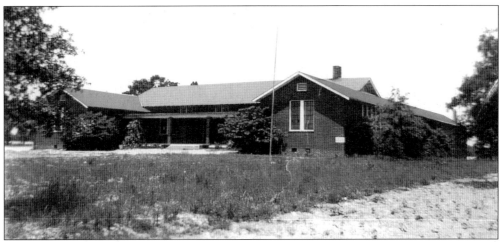

[MIDWAY SCHOOL, B5, *c.* 1930]. The Midway School site is on the north side of Jefferson Davis Highway (US #1) at Hall Road (KC #306). School District #4's Midway High School was built in 1923 with grades 1-11 and was a consolidation school that served students from the local one-room structures from Cassatt to Shepherd. W.B. Stevenson was the principal of the seven-teacher school in 1930. By 1950, high school students from Providence, Pleasant Grove, and Oakland Schools were consolidated in Midway High School District #3. The school closed in 1966 and the older structures were demolished in 1976.

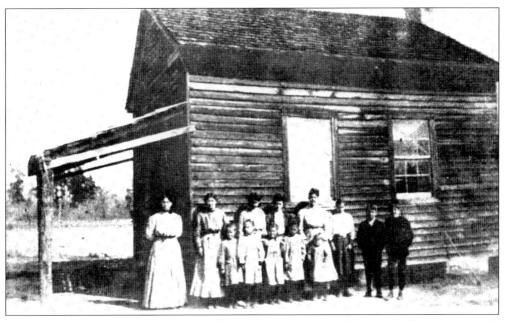

[CLASS PICTURE AT GUMBERRY SCHOOL, A6, 1906]. In 1900, Gumberry School was in Antioch School District #3,which had 2 white schools and teachers with 80 students in a 54-day term. The image above of the 1906 school includes the students and teacher, Mrs. M.M. Pearce. Their school library began in 1908. A new one-room Gumberry School was built in 1910 for $350. By 1913, the seven-grade school had 25 students in a 100-day term. It was located a half mile south of Old Stagecoach Road (KC #15) between Mt. Zion (KC #549) and Timber Creek Roads (KC #451). It no longer stands.

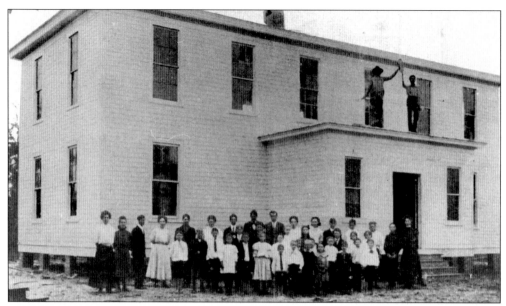

[CLEVELAND SCHOOL, A2, 1923]. In 1900, Cleveland District #2 had 4 white schools and 4 white teachers that taught 181 students in a 128-day session. The Cleveland school library was established in 1904. By 1913, this school was a two-teacher unit that had 10 grades and 63 students in a 160-day term. School District #2 had an estimated budget of $3,665 in 1919, when L. Barnes was the principal of the Cleveland School. The school was located north of Black River Road (KC #12) on Cleveland School Road (KC #91).

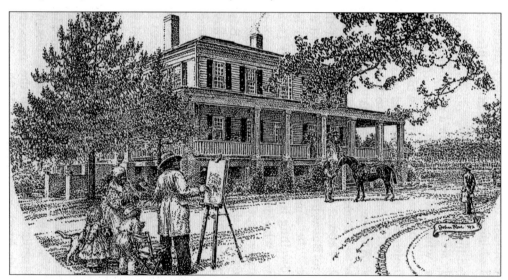

[PLANE HILL (CHARLOTTE THOMPSON SCHOOL), A3, c. 1890]. Burwell Boykin conveyed the land to S. Hunter who built this home in 1817. The name Plane Hill was given to this site by Stephen D. Miller (1787–1838), who was governor from 1828 to 1830. A.H. Boykin created a terraced garden on the estate and renamed it "The Terraces." After the Cleveland School fire of 1923, Charlotte Thompson gave her home to the county for a school, which was named after her. In 1930, V. Harvey was the principal of the seven-teacher school. The school is located near the intersection of Charlotte Thompson School Road (KC #93) and Cantey Lane (KC #92).

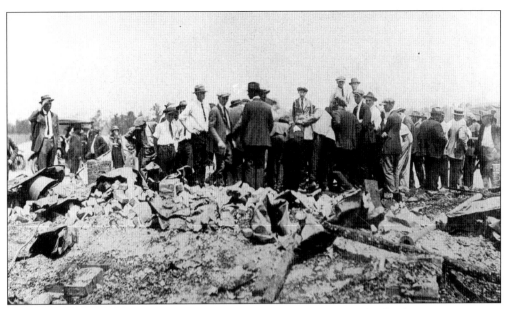

[RUINS OF CLEVELAND SCHOOL, 1923]. On May 17, 1923, the Cleveland School's commencement was attended by 300 people in the second floor auditorium. At about 9 p.m., a fire started on the small stage. The audience was trapped when the narrow wooden stairs collapsed. By 10 p.m., the building was a heap of smoldering ashes and 77 people were dead. A mass grave was dug for the 65 unidentified bodies and the funeral was attended by 5,000. This disaster caused a new state law that created rigid standards for the construction of second-story classes and stairways. Due to this law, many two-story schools closed off their top section, or built outside fire escapes.

[BEULAH METHODIST CHURCH, c. 1920]. Beulah's congregation was organized in 1877. John Brannon deeded the site to the church that year. The church above was built in 1907. Lumber for the church was cut and finished at F. Arrant's saw and planer mill at Hermitage Lake. Many members of their congregation died in the Cleveland fire of 1923. Beulah Methodist Church faces Black River Road (KC #12) about a half-mile west of the Cleveland School site.

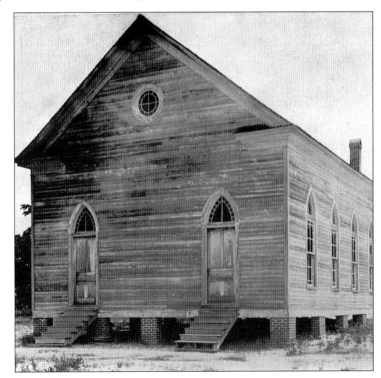

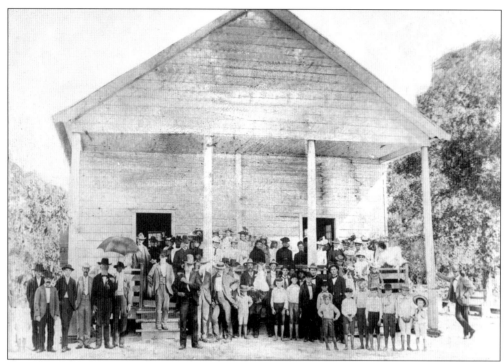

[PINE TREE PRESBYTERIAN CHURCH, C. 1890]. The original site for this church was on Benjamin Perkin's Pine Tree Plantation near Big Pine Tree Creek. Rev. M. Frazier was the minister from 1820 to 1825. The church site was moved four miles east to the head of Bell Branch south of Cassatt in 1850. The 1890s picture above was at the second site. After the depots at Bethune and Cassatt were built, the congregation split into two groups and each had a new site near a depot. Rev. G. M. Howerton was the pastor for both new churches. The structure above burned in 1912.

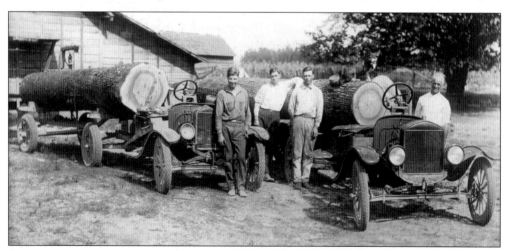

[LOGGING IN CASSATT, C. 1930s]. The timber industry became a more reliable source of revenue for farmers in the sand hills when the harvest prices from cotton, tobacco, and other crops dropped and the annual earnings of these crops produced limited profits for land owners. During the 20th century, entrepreneurs with mobile steam-driven sawmills began traveling from farm to farm harvesting the trees.

72

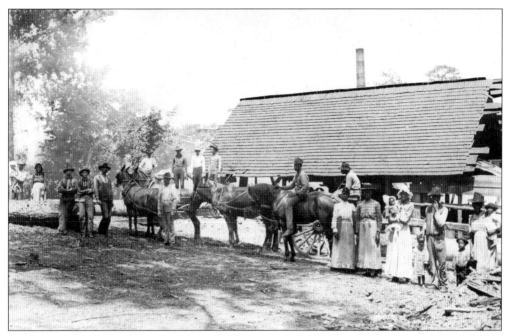

[CHARLES PERKINS'S SAWMILL, PINE TREE PLANTATION, *c.* 1910]. Benjamin Perkins acquired a large tract of land near Big Pine Tree Creek and created Pine Tree Plantation. He had a dam built on the creek to obtain waterpower to drive a sawmill that could cut the lumber for his second home. He also established a grist and flour mill on his plantation. Benjamin died there in 1841. His son, Charles Perkins (1799–1872), continued and expanded the saw mill. The image above shows Charles's saw mill in 1910. The mill provided jobs for a large work crew that continuously furnished saw-hewed boards to the lumber yards and the construction industry in that locality.

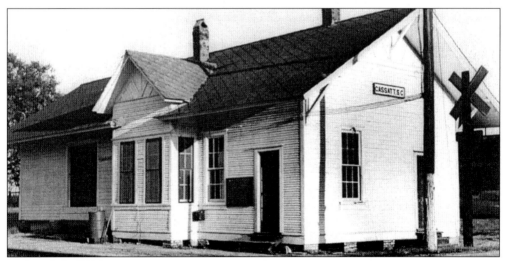

[SEABOARD RAILROAD DEPOT, CASSATT, *c.* 1917]. The Seaboard Airline Railroad constructed a Cassatt fuel stop and depot in 1899. The depot was named after a Mr. Cassatt who was once the president of the Pennsylvania Railroad Company. This site became the pivotal source for the evolution of this community with commerce coming in and going out. In 1910, the population of Cassatt was 60.

73

[ANTIOCH SCHOOL, A5, *c.* 1930]. In 1900, the Antioch School District #3 white system had 2 one-teacher schools with 80 students in a 54-day session. In 1913, the one-room school had 55 students and 7 grades in a term of 100 days. By 1915, the school was shifted to a new district and received a new two-room building. The following year L.M. Britton was the principal of an 83-student school that had a 175-book library. The view above shows the enlarged 1930 school when D.W. Traxler was the principal of the seven-teacher unit that had been shifted to District #6. In 1950, Antioch had become High School District #8 for students in that area. The school was near Antioch Baptist Church (c. 1824) during this era and on a road of the same name.

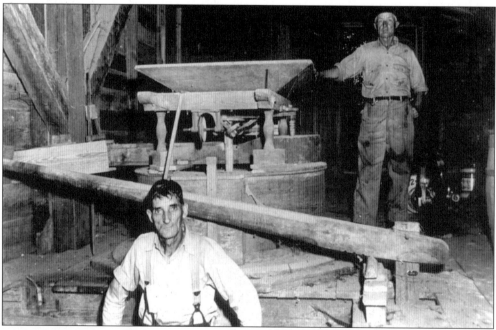

[RATCLIFF GRIST MILL, SANDY GROVE, *c.* 1920s]. The Ratcliff Grist Mill ran from the waterpower generated from the Ratcliff Mill Pond Dam on the Black River by the Old Georgetown Road. The structure was built of broad-axed hand-hewn timbers and put together with wooden pegs. Flour and grits were milled by grinding the selected grains between two heavy millstones. The flour or grits were collected in a bin below the stones. This interior mill scene pictures W.T. Ratcliff standing in the background and miller S. Capell in the foreground.

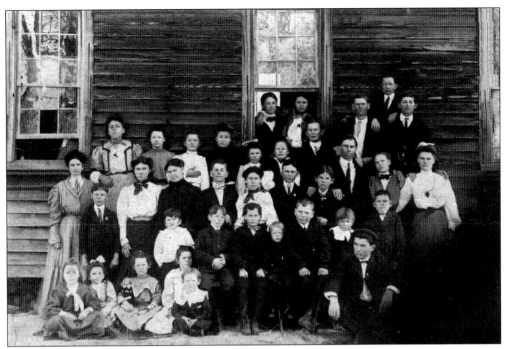

[CLASS PICTURE AT CENTRAL SCHOOL, B3, 1910]. The 1900 District #5 School system had 5 one-room schoolhouses and teachers that taught 156 children in a 100-day session. By 1906, a school library was established at Central School. The one-room 1913 school had 8 grades and 43 students in a 120-day term. In 1930, R.B. McCaskill was the teacher of a one-teacher facility. The first Central School site was near the end of the property of R. Hall. The second site was near the Sandy Grove Church and was on Old Georgetown Road East (KC #535) near Old Stagecoach Road (KC #15).

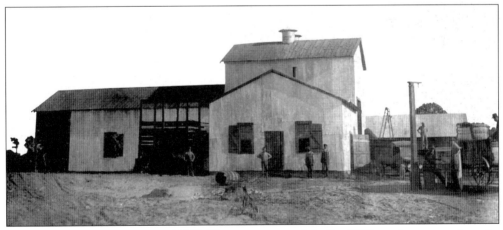

[RATCLIFF COTTON GIN, CASSATT, 1926]. The waterpower of the Ratcliff Dam also ran a cotton gin. Mules were used to power the screw press, which packed the ginned cotton into bales. After the fire of 1924 destroyed the Sandy Grove mill facilities, Wade Ratcliff moved his cotton gin to Bethune in 1924, and then established one in Cassatt in 1926 near the railroad. The gin takes field cotton and separates the seeds, hulls, and trash from the cotton fibers and then bales it. Seeds can be processed for cotton oil and the hulls made into cattle feed.

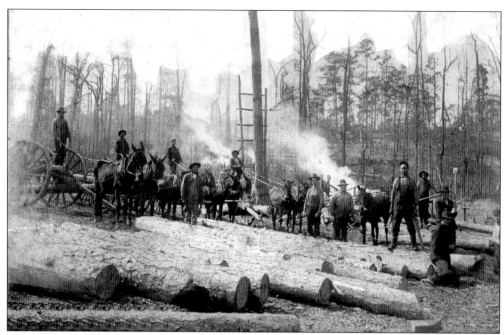

[WADE RATCLIFF SAW MILL, SANDY GROVE, *c.* 1901]. The Ratcliff Mill was at the dam that created the Ratcliff Mill Pond on the Black River just off Old Georgetown Road. The water-powered saw mill could cut 100 feet of boards per day. Boards sold to neighbors were used to build simple caskets to bury the dead. A steam engine was used in 1900 that could cut 300 feet a day. Ratcliff was cutting and dressing lumber for five lumberyards by 1912. Later, they shifted to diesel power that could cut 1,000 feet of timber a day. The mill site was on Ratcliff Pond Road.

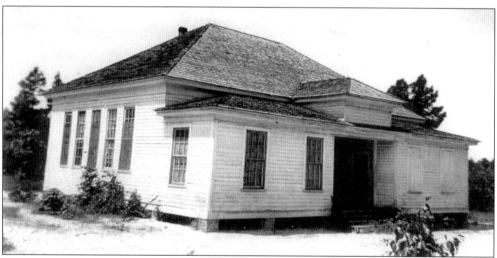

[OAKLAND SCHOOL, B1, *c.* 1930s]. Oakland School District #25 had 2 white schools with 2 teachers for 99 students in a 32-day session in 1900. Oakland established a library in 1906. By 1913, this one-room, seven-grade school had 47 students in a 120-day term. A new two-room school was built in 1915. District #25 had a $463 budget in 1919 for its schools. L. Bowers was the 1930 principal of the two-teacher facility that was on Oakland School Road. In 1950, the students of Oakland School transferred to Midway High School.

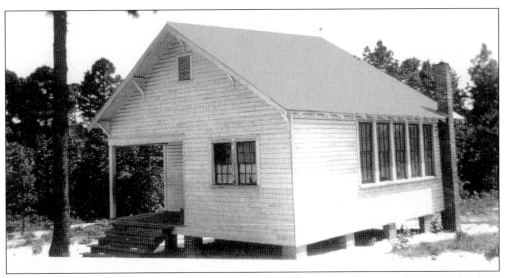

[CANTEY HILL SCHOOL, B4, c. 1930s]. In 1900, the African-American Cantey Hill School, in Oakland School District #25, was a one-room and one-teacher school that housed 42 students in an 8-day term. These small log structures were crude, drafty shacks. In 1913, the 70 students were in a 60-day term and the teacher made $60. Later, when the original log school was supposed to be moved, Mr. C. Yarborough felt that the original structure was in such bad condition that it could not be moved. Therefore, a new school was built near Oakland School Road close to the Cantey Hill Baptist Church off Cassatt Road.

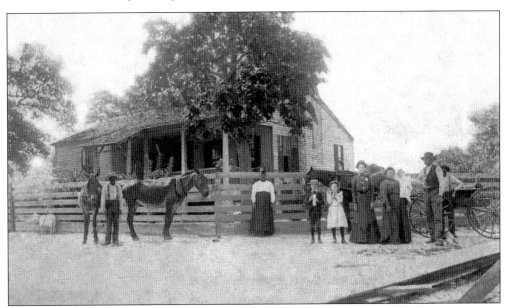

[WADE RATCLIFF HOME, SANDY GROVE, c. 1906]. The Ratcliff House was built by B.J. Ratcliff in the Sandy Grove section of southeastern Kershaw County. The family portrait includes, from left to right, two unidentified farm hands, two mules, Wm. Thomas, Emmie R.M. Taylor, B. Sullivan, Martha A.H. Ratcliff, infant Wade H. Jr., and Wade H. Ratcliff Sr. The family's large acreage permitted the production of cotton, grains, and timber and the ginning, milling, and marketing of family and neighboring harvests.

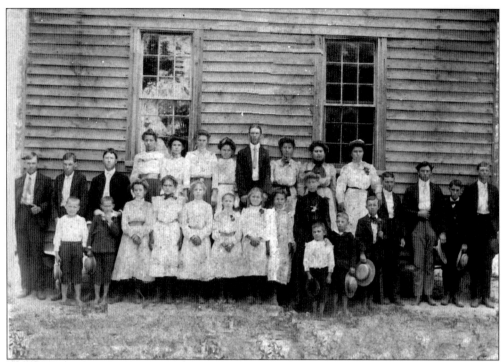

[RATCLIFF SCHOOL, CLASS PICTURE, SANDY GROVE COMMUNITY, B2, 1900]. The Ratcliff School was one of District #5's five, one-room schools that enrolled 156 students in 1900. Many rural families permitted schools to be built on their property so that their children would have a school nearby. The Ratcliff School Class picture above includes teacher F. Wilkes. The school was on the property of W. Ratcliff on Old Georgetown Road (KC #535) near the Ratcliff Pond Road and mill. B.J. Ratcliff mentioned the school in his 1899 will.

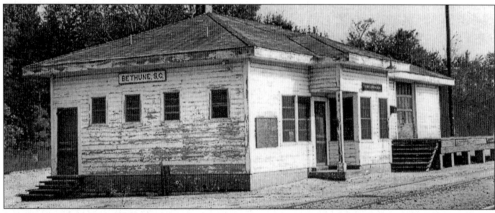

[SEABOARD RAILROAD DEPOT, BETHUNE]. The Seaboard Airline Railroad constructed their route from northern cities to Cheraw then to Bethune, Cassatt, Shepherd, Camden, Lugoff, Conquest, and Blaney in Kershaw County in 1899. The early wood-burning locomotives needed many stops to get fuel and water. Small communities developed at these sites with commerce, mail, freight, and passenger service flowing both in and out of these depots. Post offices, hotels, restaurants, warehouses, stores, banks, churches, and schools were built in these economic centers.

[FIRST SCHOOL BUILDING, BETHUNE, B6, *c.* 1910]. Bethune's 1900 District #22 included 2 white schools with 2 teachers that instructed 78 students for 44 days. Bethune's first schoolhouse was a frame two-story structure that had a one-story wing added by 1902, which can be seen in the background of the picture to the right. During the 1904 school year, Bethune's school library was established. The principal in 1910 was B. Genoble. Bethune's 1913 enrollment was 169 students in a 10-grade, 100-day term housed in an expanded four-room structure.

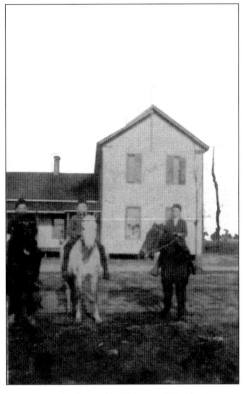

[STOKES' REUNION, 1901]. Himbrick J. and Jane H. Stokes's home was the site of the 1901 Stokes family reunion. The house was off Old Stagecoach Road (KC #15), two miles west of Tiller's Ferry on the Lynches River. These family socials were the highlight of their year and would often shift from one paternal or maternal site to another as they celebrated anniversaries, weddings, birthdays, and paid respects to beloved family members.

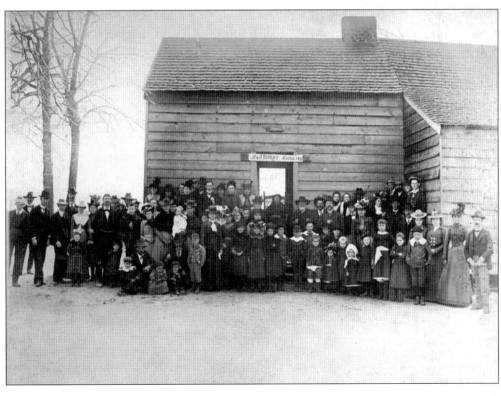

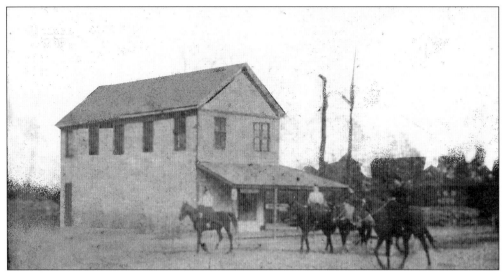

[KING'S GENERAL STORE, BETHUNE, c. 1910]. This picture shows George S. King's (1853–1923) General Store on the main street of Bethune. He also owned the King's Hotel and Dining Room. The few stores and warehouses on either side of the train depot supported the local commerce. The population of Bethune was 350 in 1910.

[BASEBALL TEAM, BETHUNE HIGH SCHOOL, B6, 1924]. The Bethune School District #22 had its brick two-story school built for $9,000 in 1915. The picture above shows the 1924 baseball team seated on the steps leading to the back door of that building. The school District #22 budget was $2,907 in 1919. A one-story brick high school was erected in 1925. The 1950 High School Consolidation Act created the Bethune High School District #6, which included Central, Gate's Hill, Shamrock, and Timrod schools.

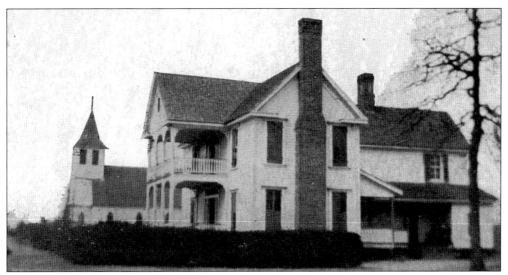

KELLY RESIDENCE AND THE PRESBYTERIAN CHURCH, BETHUNE [*c.* **1910**]. When the Seaboard Airline Railroad built its Bethune depot in 1899, a community and its churches took root. The Bethune Presbyterian Church organized with 18 members on September 29, 1901. These members transferred their church memberships from either the Pine Tree Presbyterian Church—which divided into two congregations with one in Cassatt and the other in Bethune—and Turkey Creek Presbyterian Church—both of which had devolved. Bethune's Church, a member of the Congaree Presbytery, shared Rev. G.M. Howerton with Cassatt. Both had seminary students as pastors from 1907 to 1912. Rev. J.M. Forbes was the minister from 1912 to 1925.

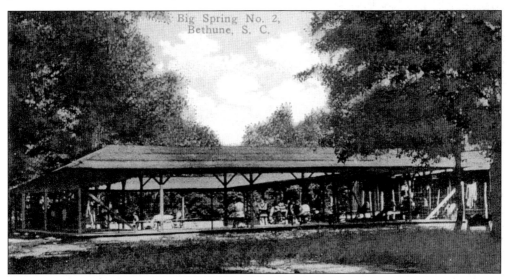

[**BIG SPRINGS #2, BETHUNE,** *c.* **1915**]. The mineral springs on the western banks of the Lynches River were included in J. Briggs royal grant of 1765 and were noted on Robert Mill's map of 1825. In 1914, Mr. Maynards founded Big Springs Resort Company and Big Springs Railway station and bottled mineral water, which was shipped across the country. Hotel accommodations were 75¢ for a meal or room or $2.50 to $3 for the American plan. Weekly rates were $12.50 to $15 and tent rentals were $2 per day or $9 to $12 weekly. Later, the resort was purchased by Dr. J.E. McLure, a Bishopville physician, who prescribed the mineral water for numerous ailments.

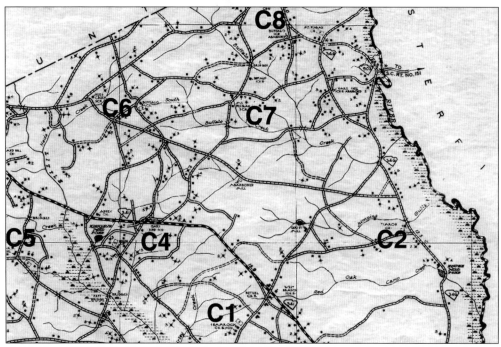

[MAP, NORTHEAST KERSHAW COUNTY, 1939]. This map shows the location of the public schools in the upper eastern boundary and the area between the Lynches River and the Little Lynches River.

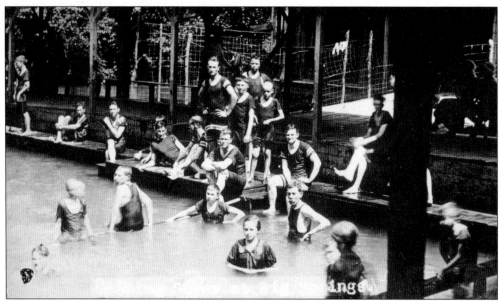

[SWIMMING POOLS, BIG SPRINGS, BETHUNE, c. 1915]. Swimming resorts were very popular recreation sites for the long, hot summer days in this era before air-conditioning. The resort had bathhouses for changing clothes and concession stands for buying snacks. Older youth would catch a morning train, travel several stops, swim, and return home on the late train. When automobiles were numerous and roads were improved, these sites lost customers to the beaches on the Atlantic.

82

Five
UPPER KERSHAW COUNTY

In 1889, the Kershaw County superintendent of education, Mr. McMahan, was concerned about the conditions of rural education. He believed the county should provide adequate education for children to stop the exodus of families from country to city for better schools. He stated that a scarcity of population and poverty of people created small enrollments and equally small funding. He noted that better teaching, salaries, equipment, courses of study, and longer terms could prepare students for life. In 1901, Kershaw County had 26 school districts segregated into white and black systems. The white system had 58 schools, 66 teachers, 2,690 students, and expenditures of $13,735. The African-American System had 49 schools, 53 teachers, 2,974 students, and expenditures of $4,859. In 1905, the town (Camden) school population had 539 white and 395 black students, whereas the rural student numbers were 1,663 white and 2,696 black students. The total days of school attendance varied but were low. By 1913, the initial 26 school districts had expanded to include Hanging Rock and Oak Ridge School Districts.

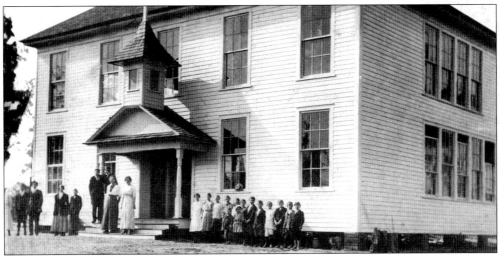

[SHAMROCK SCHOOL, C1, 1914]. The original school was torn down in 1914 and the building above was erected on the same site. This structure had two large classrooms on the ground floor and one classroom and an auditorium on the second floor. Shamrock School and Shamrock Baptist Church are located about six miles northwest of Bethune and face Porter Road (KC #42), one mile south of Bethune Road (SC #341). C. Alexander and F. Price were the teachers in 1914. Teachers changed annually. Shamrock School District #34 had a budget of $724 in 1919. Classes were held here throughout the 1920s and 1930s. The school districts were consolidated in May 1950 and these students were sent to Bethune High School District #6.

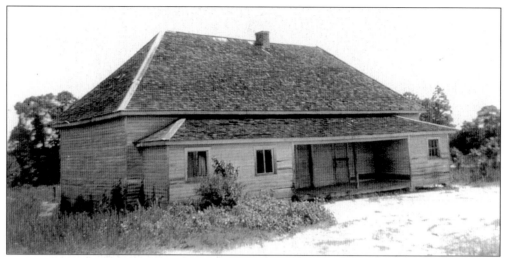

[**PLEASANT GROVE SCHOOL, B7, *c.* 1920s**]. Pleasant Grove School District #42 was not one of the initial 26 school districts in 1900. It may have evolved out of Beaverdam District #18 to become one of the dozen new schools built in 1909 at a cost of $6,700. S. Boyd taught at Pleasant Grove in 1914. The District's funding for 1919 was $320 when it had 61 students and O. Yardley was the principal. J.B. Ratcliff was the principal of this two-teacher school in 1930. This site was on Beaverdam Road (KC #526) north of Beaverdam Creek and Robinson Town Road (KC #309). In 1950, the eighth-grade students of Pleasant Grove went to Midway High School District #3.

[**PROVIDENCE SCHOOL, C3, *c.* 1930s**]. In 1900, School District #9 had 4 white schools and teachers instructing 202 students in a session of 96 days. In 1906, a school library was established at Providence School. Both Providence and Shaylors Hill School were consolidated in a new building in 1912 that cost $900 and was placed in District #15. The following year, this one-room school had 36 students, 7 grades, and an 80-day term. District #15's 1919 estimated budget was $162. A.F. Hilton was the 1930 principal of this one-teacher structure. This school was located on Providence Road (KC #59) by Beaverdam Creek two miles north of Providence Baptist Church. In 1950, the high school students went to Midway High School.

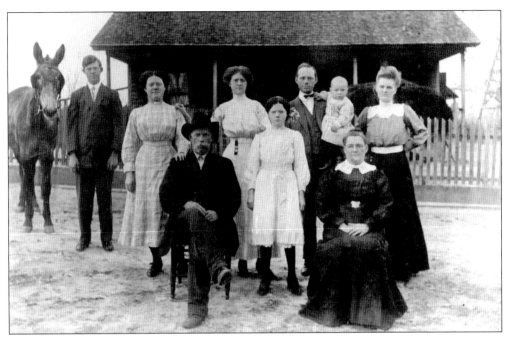

[THE BAXLEY HOME, 1911]. The John E. Baxley family portrait was taken at their home eight miles northwest of Bethune on Mill Creek Road [KC 387]. The adult children in the back row, from left to right, are Daniel E. (1895–1982), Piety E.B. Polson (1892–1967), Cornelia B. Cassady (1890–1927), Ashley H. (1884–1968), Fannie W.B. (1890–1950), Thurman A. (1910–1982), Lydia C.B. Stephens (1898–1974), their father John E. (1855–1929), and their mother Lydia L.V. Hall (1861–1952). A mule was often a rural family's most valuable possession and was often included in a rural family portrait. Baxley's mule was called "Old Belle."

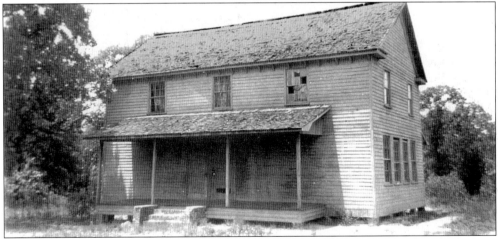

[TIMROD SCHOOL, C2, c. 1930s]. The Timrod Baptist Church was organized in 1896 and their 1901 sanctuary was near the one-room Timrod School. School District #6, Timrod, had 1 teacher in 1900 and 48 students in a school term of 20 days. J.M. Watts was one of the early teachers. In 1905, the school library was established. By 1913, Timrod had a 7-grade curriculum and a 60-day term. The structure was improved into a two-room building in 1915 and later a two-story edifice was built. Its site was west of Timrod Road [SC #346] at Mangum Road [KC #521].

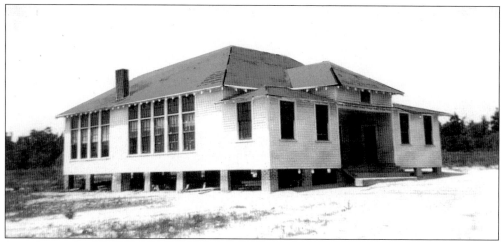

[GATES FORD SCHOOL, C4, *c.* 1930s]. Abney School was near Abney Crossroads in School District #7, six miles southeast of the town of Kershaw. In 1900, it was 1 of 3 one-room schools with 138 students in a 76-day term. Abney had one teacher in 1913 instructing 39 students in a 100-day term. By 1923, Abney was replaced with a 1920s-style Gates Ford School in District #7, which was named after Gates Ford Church, a mile east of the Abney's site on Bethune Road (SC #341). Gates Ford became a two-teacher school in 1924. B. Arnold was the principal of Gates Ford in 1930. It was a three-teacher unit by 1933. These students went to Mt. Pisgah High School District #2 in 1950.

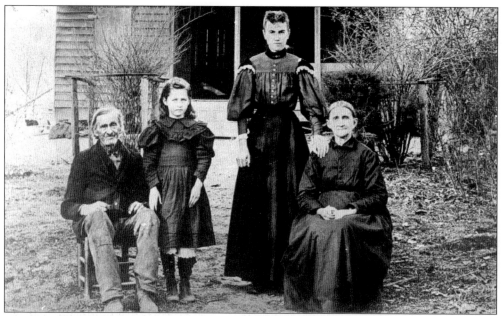

[JAMES CATO'S FAMILY, MT. PISGAH, 1897]. James Cato (1824–1907) received a state grant of 420 acres in 1839, when he was 15 years old, and built the house above. Cato fought in the Civil War and spent time in a federal Civil War prison. He and his wife, Sarah L.B. Cato (1831–1905), and their two grandchildren are shown above in a 1897 family picture. Cato helped found the Bower's School in the Mt. Pisgah section. He served the Mt. Pisgah Baptist Church as treasurer, clerk, and deacon and was the first superintendent of the Sunday school.

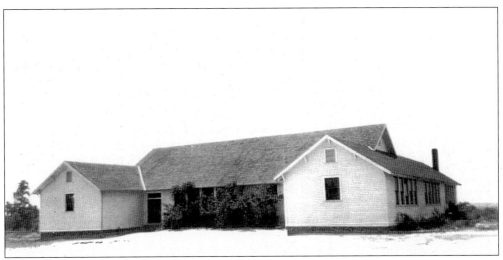

[MT. PISGAH SCHOOL, C7, *c.* 1930s]. The School District #24 in 1900 was named Hardshell School and was a one-room school with 66 students in a session of 18 days. In 1916, the new Mt. Pisgah Elementary School was built and I.B. Gardner was the principal of the two-teacher frame school. Mt. Pisgah had 100 students and a $472 budget in 1919. The county also built a high school in this community and R.M. Foster was the 1930 principal of the 13-teacher facility. This site was seven miles east of the town of Kershaw in the northeast corner of Kershaw County near the junction of Mt. Pisgah Road (KC #31) and Jones Road (SC #157).

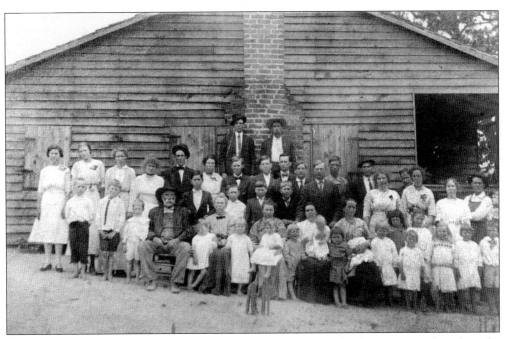

[GARDNER FAMILY REUNION, BUFFALO, 1916]. This Isaac Gardner family reunion gathered on the 61st birthday of Mary Ann Baker Gardner (1855–1936), wife of Isaac Gardner (1846–1938), at their home in the Buffalo community in May 1916. At the time of Isaac Gardner's death, he was Kershaw's oldest Confederate veteran. He grew up in the Flat Creek section of Lancaster County.

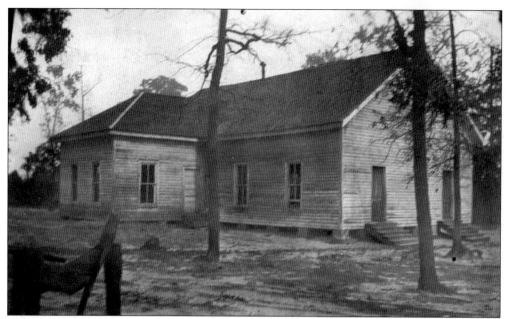

[**Mt. Pisgah Baptist Church**, *c.* **1915**]. The Mt. Pisgah Baptist Church was organized in 1837 and met in the local schoolhouse for its monthly service. The first pastor was Rev. W.T. Jones and the first house of worship was built in 1847. W. Holley was contracted to build their second structure in 1894 at a cost of $176. The sanctuary was enlarged and remodeled by adding two wings in 1915. The present structure was raised in 1928. This site is between the junction of McBee highway (SC #903) and Holley Road (KC #61) west of Lynches River.

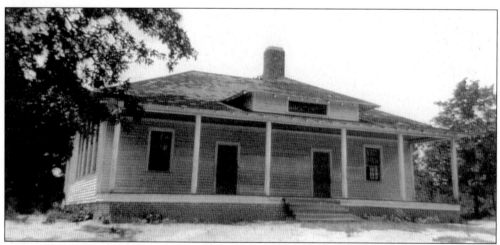

[**Ned's Creek School, C6,** *c.* **1930s**]. The Ned's Creek School, originally in the Abney School District #7, was built in 1912 at a cost of $600. It was a one-room, one-teacher school with 36 students in an 8-grade curriculum and a 100-day term. Later, a new series of districts were created with Ned's Creek becoming School District #31. In 1919, M. Truesdale was the teacher and it was funded at a $416 level. The 1930 two-teacher school above had P. Belk as the principal. This site is near the junction of Buffalo Creek Road (KC #305) and Jones Road (SC #157). It was named for the creek that was near the school. The structure became J.W. Cato's home in 1944 and burned down in 1977.

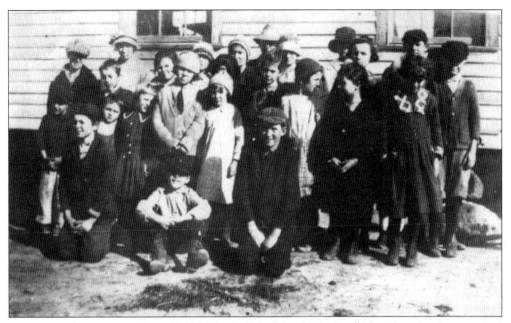

[**BUFFALO SCHOOL CLASS, C8, *c.* 1919**]. The Buffalo School District #14 white school system had two one-room frame buildings with 2 teachers instructing 85 students in a 48-day session in 1900. The one-room Buffalo School had evolved into a seven-grade unit in 1913 with 33 students in an 80-day term. District #14 was funded at $714 in 1919. The Buffalo School site, in northeast Kershaw County, was near the McBee Highway (SC #803) and Ellis Road (KC #32).

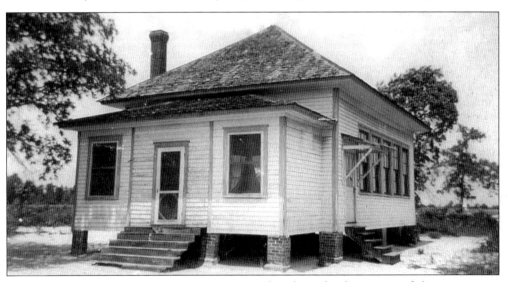

[**OAK RIDGE SCHOOL, C5, *c.* 1930s**]. In 1900, Oak Ridge School was one of three one-room schools in Abney District #7. In 1908, a school library was established at Oak Ridge. The county divided Abney's District #7 in 1910 and shifted the one-room Oak Ridge into a new District #28 where it had 50 students in a 7-grade curriculum and a 75-day term. Its 1919 budget was $595. E. Carson was the 1930 principal of this two-teacher edifice. The site of this school was on Oak Ridge Church Road (KC #374) and Providence Road (KC #359). In 2002, this site is in Lancaster County.

[BUFFALO BAPTIST CHURCH AND GRAVE, *c.* 1937]. Buffalo Baptist Church was founded in 1871. The sanctuary above may have been the "new house" its congregation reported under construction at the Moriah Union meeting in 1892. In the early 1940s, an addition was built on the front for a vestibule along with three Sunday School rooms and a steeple. This church was replaced by the present building in 1961. The church is located on Lockhart Road (KC #20) south of Jones Road (SC #157).

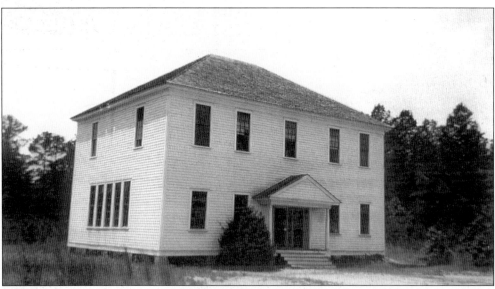

[THREE "C'S" SCHOOL, D3, *c.* 1930s]. The Three "C's" School was named after the Charleston, Cincinnati, and Chicago Railroad line built in 1887 that connected Camden to Lancaster. In 1900, the Three C's school was placed in District #13 and had a one-room schoolhouse with 1 teacher and 32 students in a 36-day term. Three C's developed into a two-teacher, eight-grade school by 1913 with 57 students in a 120-day term. A new school was built in 1915 and a library was established the next year. In 1950, these students went to High School District #7 in Kershaw. The school site is south of Three C's Road (LC #764) and Youngs Bridge Road (LC #271) in Lancaster County in 2002.

[MAP OF CENTRAL KERSHAW COUNTY, 1939]. This map shows the location of the public schools in the upper central area from the town of Kershaw south down US #521 and US #601. It includes the area between Ebenezer Road on the west and Providence Road on the east. Sectional maps are found on pages 60, 68, 82, 98, and 110.

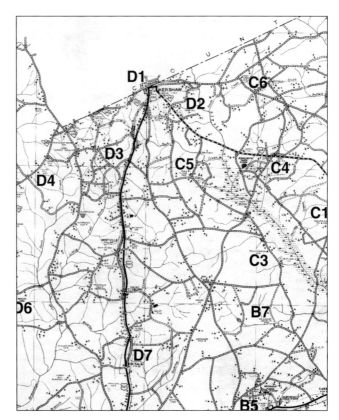

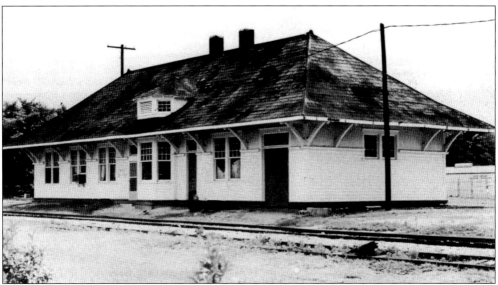

[KERSHAW DEPOT, c. 1950s]. Capt. J.V. Welsh, a sawmill owner, persuaded the Three C's Railroad Company to place a depot on his property in 1887 by promising to layout a town. He wanted Haile Gold Mine along with lumber, turpentine, and farming interests to have a local shipping site mid-way between Camden and Lancaster. Kershaw was incorporated in 1888. O. Floyd was the first mayor of Kershaw in 1902.

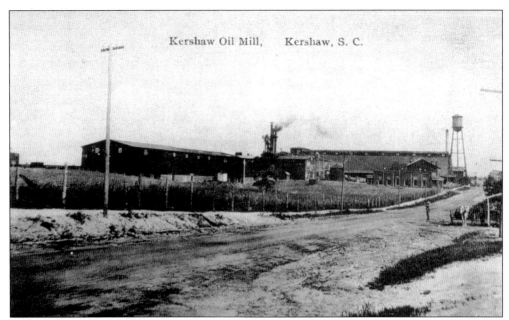

Kershaw Oil Mill, Kershaw, S. C.

KERSHAW OIL MILL, KERSHAW, [c. 1913]. John T. Stevens founded the Kershaw Oil Mill in 1902 along with a group of local businessmen. Oil mill property was used to construct the Springs Cotton Mill, of which Stevens was a partial owner. The oil mill was one of the largest in the South.

[MAIN STREET, JULY 4, 1913, KERSHAW]. The 1912 closing of the Haile Gold Mine had dampened the prospects of the local merchants. However, the 1913 celebration of the Fourth of July was a large event with numerous floats. Everyone was pleased about the completion of the new cotton mill facilities. The revitalized economy promised 400 mill jobs, new residents, visitors, retailers, banks, hotels, warehouses, and expanded shipping at the depot. In 1910, Kershaw had a population of 800.

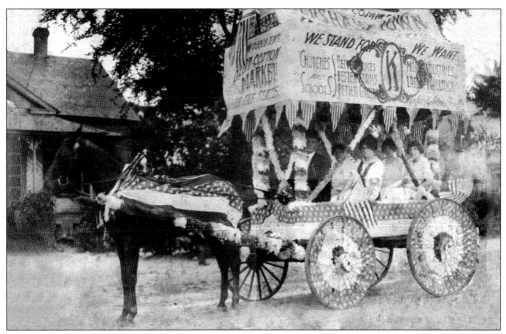

[CHAMBER OF COMMERCE FLOAT, KERSHAW, 1913]. The town celebrated the Fourth of July holiday as residents basked in the new glow of future prosperity brought about by the completion of the new Kershaw Cotton Mill. Banks and local merchants were pleased that the economy would be developing with the added funds used to equip, maintain, and expand the industrial base.

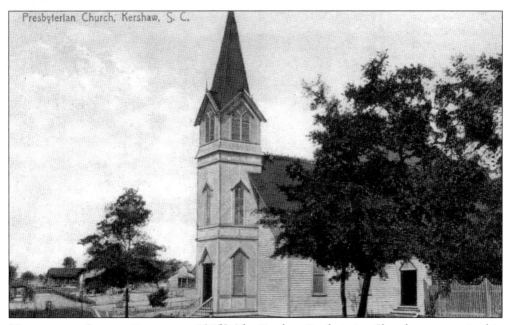

[PRESBYTERIAN CHURCH, KERSHAW, c. 1915]. The Kershaw Presbyterian Church was organized in 1891 with 16 charter members. Rev. B.P. Reid was the first minister. They purchased an old frame Baptist church in 1893, moved it to the corner of Matson and Marion Streets, and worshipped there until they sold it in 1917. Their manse was built in 1900.

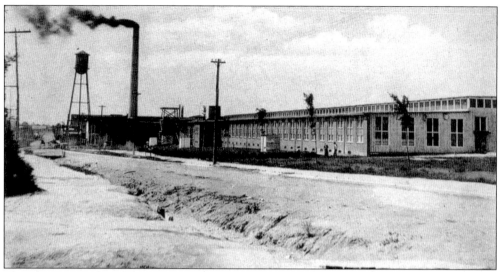

[KERSHAW COTTON MILL, KERSHAW, *c.* 1915]. Local leaders became interested in establishing a cotton mill in 1912. Finally, Springs Cotton Industries agreed to support and build a cotton mill, which was completed in June 1913. L. Springs was elected president and J.T. Stevens was elected vice-president. The mill had a capital of $200,000 and employed almost 400 workers who lived in a 40-house mill village. It was built on the north side of town on land owned by the Kershaw Oil Mill. J.T. Stevens was the principal stock owner. It began as a weaving plant making shade goods and lawn cloth.

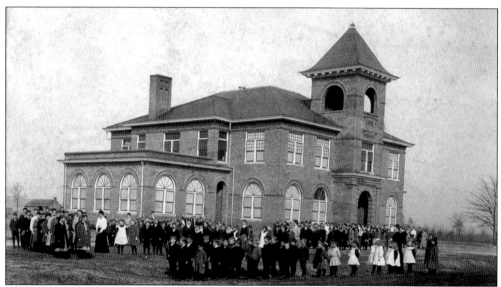

[KERSHAW SCHOOL AND CHILDREN, D1, 1907]. A large, frame school building was built in 1888. By 1898, the Graded School had nine grades. In 1903, Kershaw's white population was 550 residents and 254 students. The cornerstone for the new Kershaw Graded School was laid on September 9, 1905. The brick school cost $12,000. The Kershaw School was in Joint School District #40 supported by Kershaw and Lancaster Counties. The Kershaw School, in 1913, had 6 teachers and 90 students in a 180-day term. W.H. Scott was the principal in 1916. In 1927, a brick high school was erected.

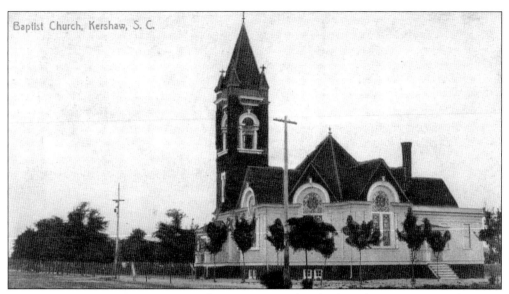

[BAPTIST CHURCH, KERSHAW, c. 1910]. The First Baptist Church of Kershaw was organized in 1881 as Laurel Hill with Rev. J. Falls as the pastor from 1881 to 1882. The second frame building was destroyed by fire and was replaced by a brick structure in 1916.

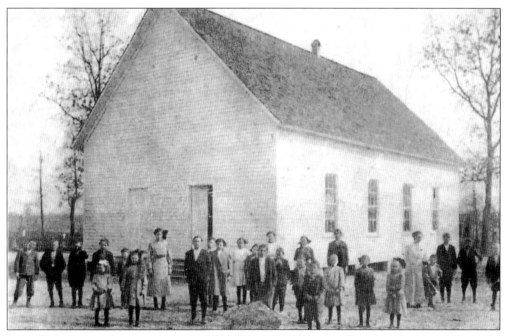

[SAND HILL BAPTIST CHURCH, D2, c. 1915]. The Sand Hill Baptist Church was organized in 1814 and originally used a log structure. The one-room frame sanctuary above was used from 1900 to 1955. The Sand Hill 1900 School District #26 had a one-room frame building on the same church lot that housed 64 students in a 20-day session. In 1904, a school library was established. The eight-grade school, in 1913, had 45 students in a 122-day term. Its location was one and a half miles southeast of the town of Kershaw and was located on Sand Hill Road (KC #496) off Bethune Road (SC #341). The site is in Lancaster County.

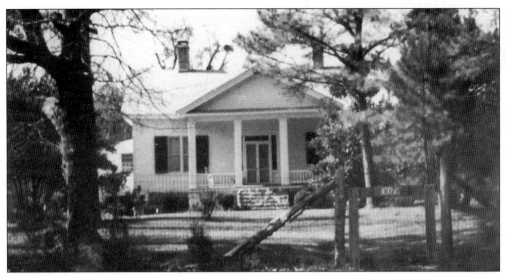

[BEAVER CREEK ACADEMY *c.* 1930]. The establishment of the Beaver Creek Academy began in 1816 and classes started in 1817. Mr. Britton was the teacher. The site was some 20 miles north of Camden. In 1852, the building was given to S. Stinson as a wedding present. It was dismantled and rebuilt in Liberty Hill as a home with the same configuration. It is still used as a home in 2002.

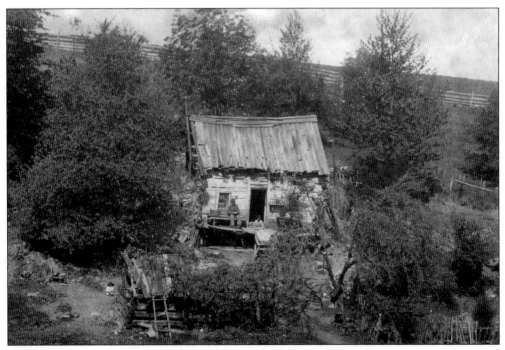

[RUSTIC HOME SITES *c.* 1910]. Images of humble home sites were seldom documented. This view shows the fragile day-by-day lifestyle of those living in near poverty. In this rare scene, an elderly couple sits on the slanting front porch of this dilapidated log cabin. A make-do attempt to keep the weather out is made by packing mud between the logs, using mismatched windows, planks one-over-another for the roof, and odd sections of metal stove pipes to replace the old chimney.

96

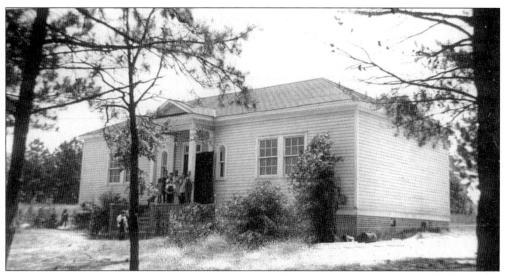

[THORN HILL SCHOOL, D4, C.1930s]. Kershaw County built one white schoolhouse for $400 in 1910, which increased their school districts to 30. Thorn Hill School is District #30. Thorn Hill was a two-teacher school in 1924 and L.C. Thornton was the 1930 principal. In 1950, the students went to DeKalb High School. This site was on Ebenezer Road (KC #597), a short distance south of Thorn Hill Baptist Church on the west side of Flat Rock Creek. In 2002, this area is in Lancaster County.

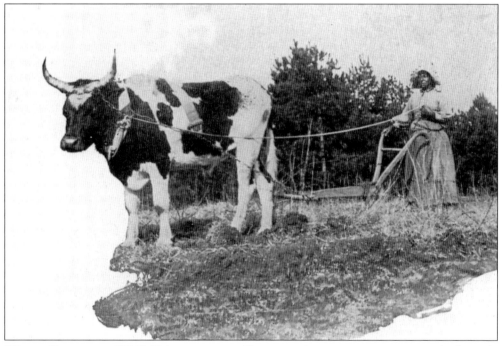

[WOMAN PLOWING, C. 1910]. Using an ox or milk cow to plow was a common scene in the early 1900s. Many rural families had limited income and means. At this time, both parents tilled the soil and tended the crops, chickens, and hogs when they were not working on neighboring farms for small sums of money. The ox was the beast of burden for these families.

[STONE QUARRY, STONEBORO, c. 1910]. Dr. T.J. Strait began mining granite on his plantation in 1902. Ox-drawn wagons hauled the blocks to Heath Springs. Successive groups mined the granite with the Southern Granite Company mining it in 1905. A railroad was established to haul the granite, larger plants were built, and thousands of tons were sold and shipped. However, the company's expenses exceeded granite sales and the quarry went bankrupt in 1914. The Stoneboro granite industry never recovered.

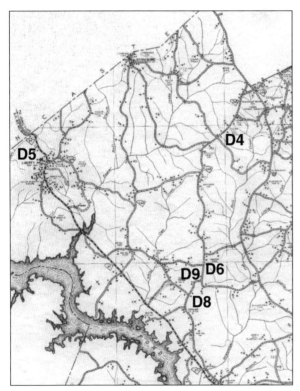

[MAP OF NORTHWEST KERSHAW COUNTY, 1939]. This map shows the location of the public schools with site codes from the northwestern boundary eastward to just beyond Flat Rock Road (KC#48) and as far south as Grannies Quarter Creek. Some of the northern area in 2002 is a part of Lancaster County.

[BEAVER CREEK BAPTIST CHURCH, *c.* 1930s]. The Beaver Creek Baptist Church *c.* 1800 was organized by Hugo Stearns with Daniel Marshall, itinerant preacher. The first log structure was said to have been burned in 1865 and a second log building replaced it. The third structure *c.* 1885, shown above, had two doors—the ladies' entrance was on the left and the men's entrance was on the right with a rail separating the two. It was also called Blackjack Church. This church site is southwest of Stoneboro on the Stoneboro Road (SC #522) in Lancaster County in 2002.

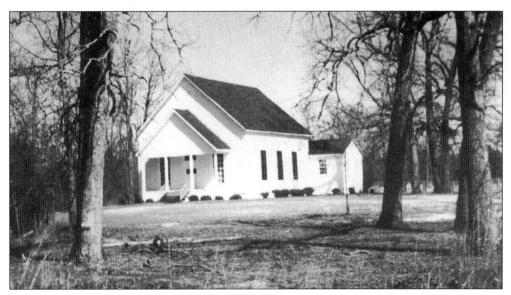

[BEAVER CREEK PRESBYTERIAN CHURCH, *c.* 1930s]. The Beaver Creek Presbyterian Church was organized in 1771. Itinerant ministers from Ireland and Scotland were the first ministers for their monthly services. Church elders would lead the services when ministers were not available. The building was erected in 1789 when it was originally called Millers Presbyterian Church. It is located on the Flat Rock Highway (KC #58) near Robinson's Crossroads and is still in use today. The site is located in Lancaster County in 2002.

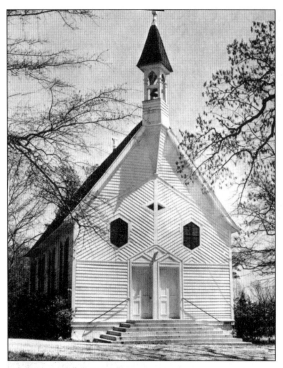

[LIBERTY HILL PRESBYTERIAN CHURCH, c. 1930s]. The Liberty Hill Presbyterian Church was organized in 1851 and the first church structure was built in 1852. The sanctuary above was designed by E.C. Jones, F.J. Hay Camden was the architect, and it was built by Mr. Hammond. Timber from the previous church was also used in this one. The church was dedicated in 1880 and is still in use in 2002. Liberty Hill had a population of 150 in 1910.

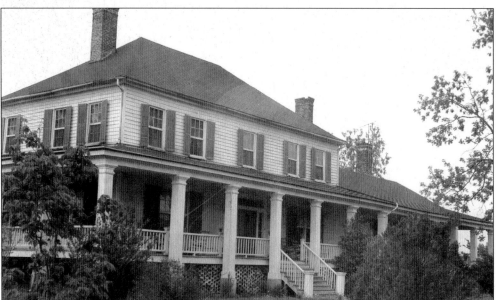

[JOSEPH CUNNINGHAM (RICHARDS) HOUSE, c. 1930s]. Joseph Cunningham of Liberty Hill was a cotton farmer. His cotton was sent down the Wateree River to the Santee docks, then to Charleston, and finally on to London. He was South Carolina's first self-made millionaire. He lost his home and plantation after the Civil War and the house was obtained by Rev. J.G. Richards. His son, J.G. Richards (1864–1941), was elected to the South Carolina House from 1898 to 1910 and became governor of South Carolina in 1926 as a democrat. He held various political positions until he died.

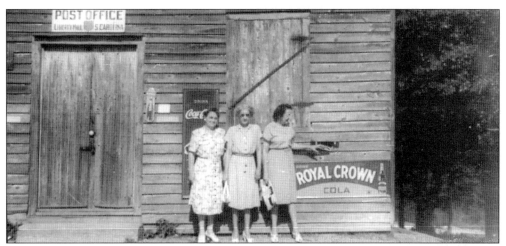

[Post Office, Liberty Hill, c. 1925]. Liberty Hill is situated on top of the Fall Line dividing the Sand Hills and the Piedmont regions. It is beside the old trail between Camden and the Catawba Indian Nation. During the colonial era, it was a likely route between Charleston and the Great Wagon Road North. Peay's Ferry was the main crossing site to Fairfield County for Liberty Hill. W.A. Cunningham was postmaster from 1907 to 1918 and C.D. Cunningham was the next postmaster. The picture above shows the location of the post office, which was located at C.D. Cunningham's store from 1921 to 1957. In 1910, Liberty Hill had a population of 150.

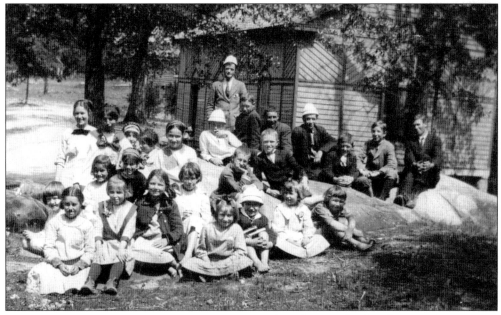

[Class Picture, Liberty Hill School, D5, 1900]. The Liberty Hill Schoolhouse, shown above, was built in 1890s. Liberty Hill School District #10's white system, in 1900, had 2 schools with 2 teachers instructing 80 students in a 52-day term. The school library was established in 1904. Liberty Hill had 35 students in 1913 in a 180-day term. J.J. Richards was the teacher in 1919, when the district was funded at $1,211. L. Richards was the 1930 principal of this one-teacher house. In 1950, these students went to Kershaw County's 7th High School District in the town of Kershaw.

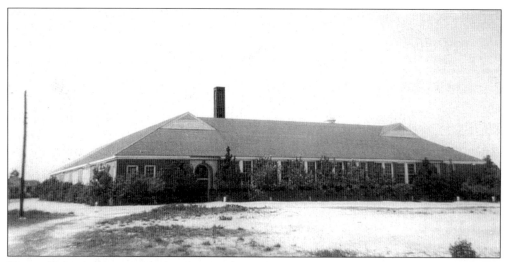

[BARON DEKALB SCHOOL, D7, c. 1930s]. The Baron DeKalb white School District #19 had 2 schools with 2 teachers and 90 students in a 48-day session in 1900. DeKalb became a two-room, one-teacher, nine-grade school in 1913,and had 61 students in a 100-day term. M.E. Lorick was the principal in 1916, when it had grown to 70 students with an expanded library of 190 books. In 1930, the principal was I.B. Truesdale. Its site was on the Kershaw Highway [US #521, #601] and DeKalb School Road [KC #126]. DeKalb High School became Kershaw's 1950s High School District #5 that served students from Thornhill to the Piedmont area. DeKalb's population was 110 in 1910.

[A GAMECOCK TRAINER, c. 1920]. Gamecock breeding and training was a lucrative sideline for those interested in establishing a flock of aggressive cocks for this illegal gambling activity. The roots of this sport go back to colonial days when the fights were held in out-of-the-way sites so that the law officers would not see or stop them. Because the sport was illegal, photographs of these events were seldom found. The image above shows one of the trainers bringing in his line of fighters. This sporting activity occurred across Kershaw County and this state. The enthusiastic followers of these events crossed all social and cultural levels of society.

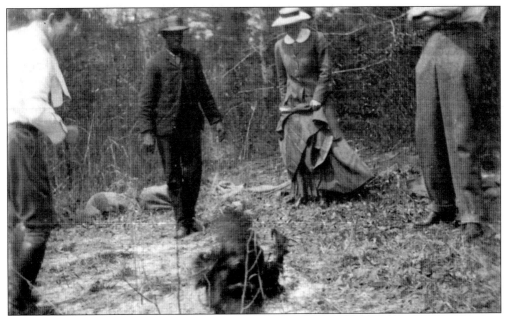

[GAMECOCK FIGHT, *c.* 1920]. These events, called Sunday Morning Fights, were scheduled when those who objected were elsewhere. Each trainer would select a cock and thrust them beak to beak at each other to create anger in the fowls. When the aggression was high enough, they were thrown together in the center of a space for a fight to the death. The spectators would gamble on which cock would win and the winning owner would receive a portion of the gambling stakes. It has been said that the losing gamecock would be cooked in a special receipt.

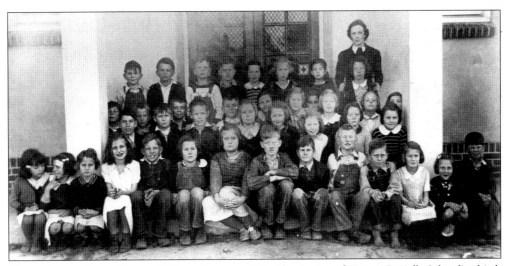

[THIRD-GRADE CLASS, BARON DeKALB SCHOOL, D7]. The image of Baron DeKalb School's third-grade class is shown above. Kershaw County's 1909 budget for the white system included the building of 10 new replacement schoolhouses at a cost of $6,700, which maintained its 53-school level. Kershaw County's 78 teachers passed the state certification tests. They were subdivided into "A," "B," and "C" ranks. fifty-seven obtained the highest percentile with "A" certificates and 5 had "B" certificates for the female teachers and 10 "A" certificates and 6 "B" certificates for the male teachers. The county's school population was 647 town students and 1953 rural students.

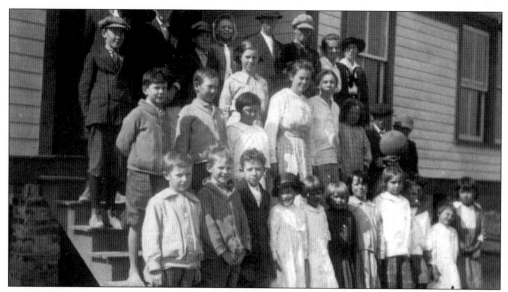

[STUDENTS, PIEDMONT SCHOOL, D9, 1917]. The image above shows the 1917 Piedmont students in front of their school. Kershaw County's dual school system was organized in 1912 and 1913 to consolidate smaller schools in various areas to modernize the educational system. In 1913, its white system had 4 town-schools with 745 students while its rural section had 48 schools with 2,137 students. These students were divided into 39 one-teacher schools, 9 two-teacher schools, 1 three-teacher building, and 3 structures that had 4 or more teachers. The African-American system had one town-school with 400 students while the rural section had 52 schools that had 3,500 students in 51 one-teacher schools and 1 two-teacher facility.

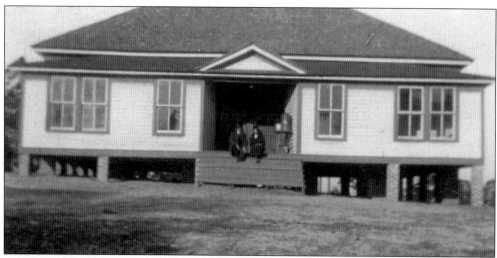

[PIEDMONT SCHOOL, D9, 1918]. The white system of School District #9's 1900 session had 4 schools with 4 teachers instructing 202 students in a term of 96 days. By 1911, the 3 remaining schools had 71 students and district #9's revenue was $1,944. Piedmont established its library in 1911. H. King was the principal the year this picture above was taken. By 1920, the two-teacher facility had 52 students in a 140-day term. I. Latham was the 1930 principal of this school. The site of Piedmont School was on Baron DeKalb Road (KC #40) west of Ebenezer Road (KC #597). In 1950, these high school students were transferred to District #5 Baron DeKalb High School.

104

[EBENEZER SCHOOL, D6]. The African-American students of the Thornhill School District #30 went to Ebenezer School, which was located at the junction of Pine Bark Road and Ebenezer Road (KC #597). Kershaw County's 1910 black school system had 50 public and 3 private schools. The county's black teachers had passed the state's certification tests and were subdivided into 4 "A," 1 "B," and 2 "C" certificates for male teachers and 4 "A," 16 "B," and 31 "C" certificates for female teachers. The student population was 1,420 boys and 1,700 girls in 51 one-room, rural schools.

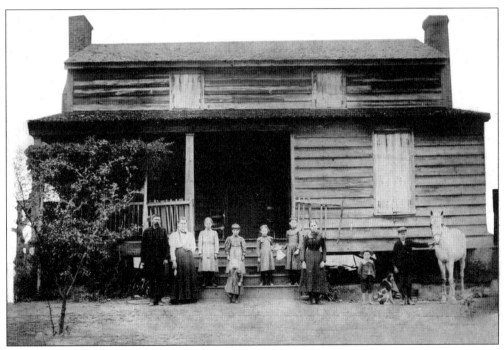

[ROBERT LOVE SMYRL HOME, 1898]. The Robert Smyrl Home is located northwest of Camden on Flint Hill Church Road (KC #346) and was built in 1853. This family portrait has the parents, children, and a visitor dressed in their best go-to-town clothes in front of their old home place. The rural photographer typically photographed a family along with their pets and the favorite work animals that they depended upon when the family planted crops and hauled their harvest to market.

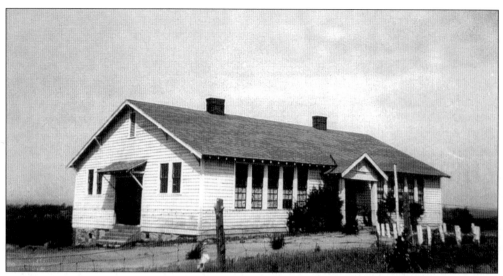

[KIRKLAND SCHOOL, D8]. The Kershaw County District #9's African-American school system had four schools, including Kirkland School, with four teachers instructing 163 children in a 64-day school term in 1900 when the county had 2,878 white and 2,504 black students enrolled in classes. Kirkland's schoolhouse, above on Flint Hill Road (KC #346), replaced the initial 1900 building with a 1920s modern-style two-room facility. The replacement of out-dated African-American school facilities was supported by the national Julius Rosenwald Fund colored school grants program, which partially funded the construction costs of the school buildings by dividing the cost between state, county, local, and grant moneys.

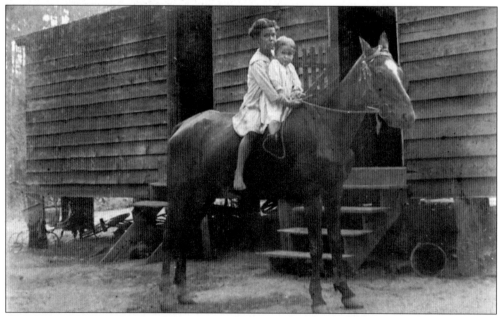

[KELLY CHILDREN AND "BILLY" THE HORSE, C. 1916]. Eva Kelly (L. Campbell), in back, and her sister Annie B. Kelly (McGuirt), in front, are pictured on Eva's horse "Billy," on which she rode to school. The family home at 2233 Flint Hill Road (KC #346) was in an area that was called Cantey Hill. The home, shown above, still stands behind their present house on the same lot.

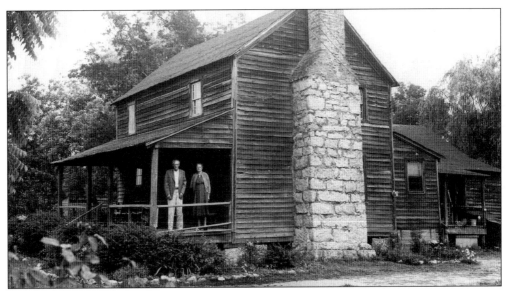

[McDowell House, *c.* 1930s]. This old Robert A. McDowell home in the Flint Hill community is thought to be over 200 years old. It is built of notched logs and hand-hewn timbers. R.A. McDowell's grandfather bought the house from Colonel Goodwyn in the 1830s. The brick and granite chimney was built in 1849. The house is located off Flint Hill Road about 15 miles from Camden and still stands in 2002.

[Matt Ferguson and "Alice" the Elephant , *c.* 1940s]. Matt Ferguson of New York and Dixie Boykin of Kershaw County claimed that an elephant could be trained to be a Kershaw County mule. Ferguson bought "Alice," an 18-year-old elephant, from a circus in Florida. M. Ferguson, who wintered at Chancefield Plantation, began training Alice on the 8,000-acre plantation. Alice, shown above with M. Ferguson, pulled plows, piled brush, and hauled logs as part of her daily chores. When Matt went into the army, Alice was sent to a zoo in Atlanta.

[**L. Pierce's Picnic at Knights Hill**, *c*. **1905**]. The Pierce family picnic shows this gathering of the Kirkwood elite who had traveled the short distance to Knights Hill to relax and remember past events. The local matrons and squires of Camden's gentry are dressed in their sporting clothes and the ladies are wearing the latest in millinery fashion for a special lunch after that day's events.

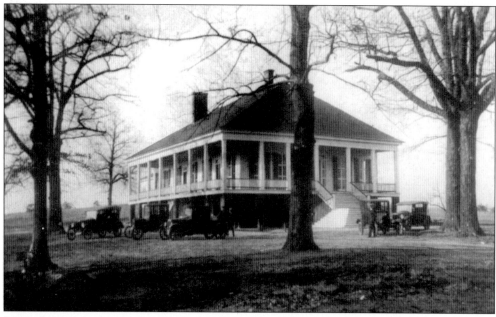

[**John Adamson's Plantation Home**, *c*. **1910**]. The Adamson's 400-acre plantation, including "The Retreat" (John Adamson's home *c*. 1827) on Knights Hill Road, was purchased in 1927 by Harry D. Kirkover and Ernest L. Woodward. These two men were the leaders in the development of the Springdale Race Track, built so that adequate lands near the Kirkwood sporting area would be available for training and racing horses.

[ST. PAUL'S CHURCH, KNIGHTS HILL *c.* 1915]. The 1868 organization of St. Paul's A.M.E. Church in Knights Hill began after the meeting of F.P. Kirkland, J.H. Brevard, J. English, M. Nettles, W. Truesdale, and Mr. and Mrs. P. Watts. Later, a frame structure was built at 852 St. Paul Road. Concerned about their children's education, St. Paul established a school in their church *c.* 1890. The teachers were Mrs. A. Sutton, followed by Mrs. F. Truesdale and then Mrs. R. Brown. The sanctuary was destroyed by fire in 1918 and was replaced in 1920. When the congregation expanded, a new edifice was built at 511 Knights Hill Road in 1976. The old vacant structure was destroyed by fire in 1993.

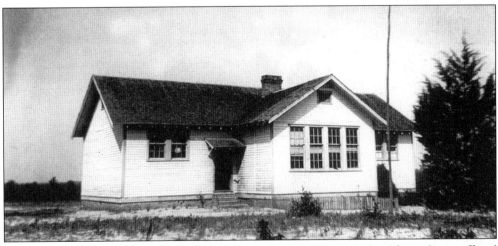

[KNIGHTS HILL SCHOOL, D10]. Knights Hill African-American school evolved from classes offered at St. Paul's Methodist Church. In 1913, the Knights Hill one-room school, in Camden School District #1, had a 5-grade curriculum and 107 students in a 100-day term taught by one teacher. The picture above shows a schoolhouse *c.* 1920, which was likely a Rosenwald Fund school. To obtain a Rosenwald Fund grant, the black community needed to raise money, locate money from white patrons, and convince district, county, and state educational offices to contribute matching funds for a Rosenwald building to be erected.

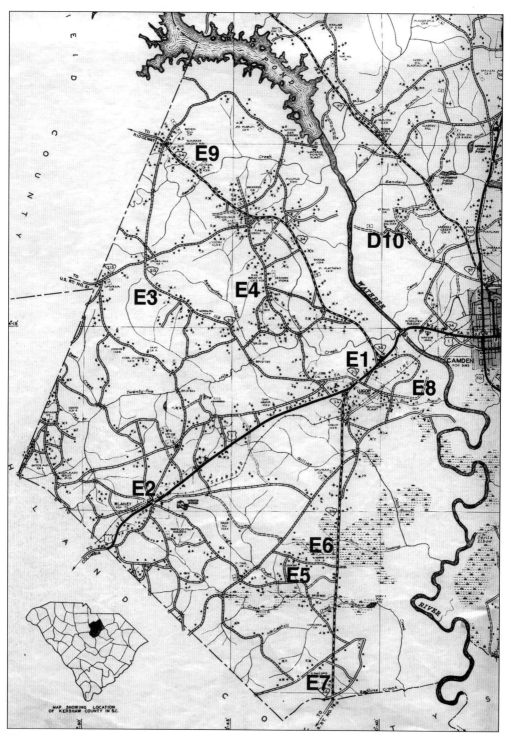

[MAP, WEST OF THE WATEREE RIVER, 1939]. This map shows the location of the public schools in the Kershaw County area west of the Wateree River.

110

Six
WEST KERSHAW COUNTY

The Wateree River was a waterway for boats and a barrier that had to be crossed for land travel. Early major freshets occurred in 1771, 1791, 1795, and 1796. The first bridge was erected c. 1827 by the Camden Bridge Company and was directed by Col. W. Nixon. Granite stones were cut miles upstream, then floated downstream by flat boat to the construction site where they became the piers for the bridge. That toll bridge lasted until c. 1831, when it was washed away. The bridge company ran a ferry that was used until 1838 when a second bridge was constructed on the original piers; however, an 1854 high-water freshet damaged that structure again. The next problem came when Sherman's army destroyed the bridge in 1865. A ferry was again used until 1872 when the county built a wooden structure, which they destroyed in 1877 because it became a danger and a menace. Other toll bridges were built later, only to be destroyed by floods

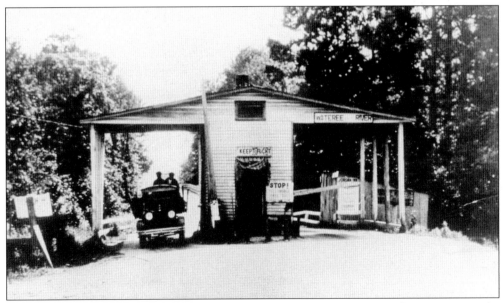

[WATEREE BRIDGE TOLLHOUSE, C. 1925]. The Camden to Columbia road (US #1) passed over the Wateree River and, from the earliest days, a toll fee was charged. The tollhouse was placed at the entrance of the ramp leading to the Wateree Bridge. After the vehicles paid the fee, they were allowed to cross the bridge.

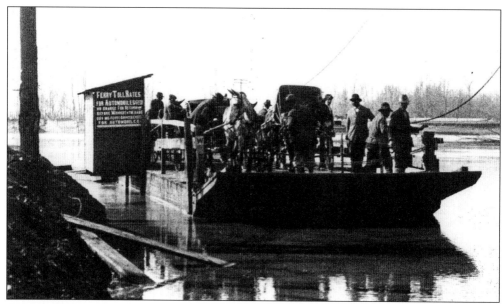

[TOLL FERRY, WATEREE RIVER, 1917]. After the flood of 1916, the ferry was back in business using two flat barges tied together that could carry several vehicles. Tolls were 25¢ per vehicle and 10¢ per passenger. The vehicles would line up at the ferry's ramp and wait their turn to cross the river. It was a slow process and, on occasion, took over an hour to complete. When the Wateree River Hardaway Dam was constructed in 1919, the floods ended and in 1920, another toll bridge was built, which lasted to the 1940s when it was destroyed by the Army Corps of Engineers. A modern concrete bridge was built over the river.

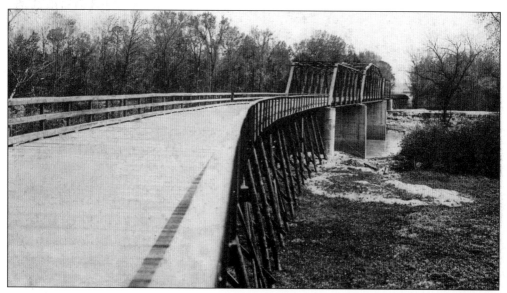

[TOLL WATEREE BRIDGE, 1910]. In 1910, the county built a free bridge at a cost of $42,000. This view shows the long wooden ramp, supported by an under-pinning of logs that stretched over the extended low marshes on each side of river, which led to the high bridge structure placed on tall pillars. The 1916 flood, with a water level of 40 feet and 4 inches, washed out this bridge. Since the county carried no insurance on the bridge, it was a total loss. The ferry was in use again.

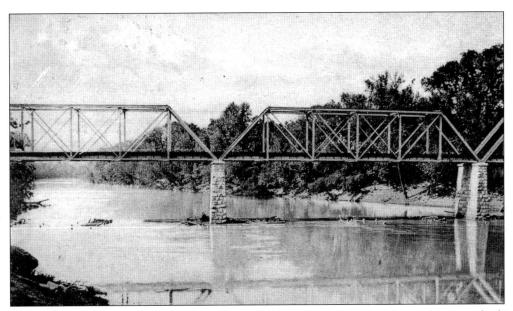

[TOLL BRIDGE, WASHED AWAY IN THE FLOOD OF 1908]. The 1883 toll bridge, shown above, was built by The Wateree Bridge Company, which was a Camden chartered company. H. Savage Sr. was the major owner. The bridge lasted until the flood of August 16, 1908. A huge pile of drifting logs and debris, at a water level of 39 feet and 7 inches, caused the bridge to give way, drowning 4 and washing 10 people down stream. H. Savage Sr. was on a raft, directing the workers, when the bridge broke away. He floated on driftwood downstream until he was rescued 15 miles away.

[LUGOFF TRAIN STATION, 1916]. In 1899, this depot and the town were named after Count Lugoff, a Russian engineer who helped build this railroad line through Kershaw County. This photo of the Lugoff Train Station was taken on July 18, 1916 when a group of Seaboard Airline Railway's passengers assembled at the railroad tracks. They were observing the condition of the railroad trestle and the Wateree River flood and speculating about when the train could cross the trestle and continue its trip. The population of Lugoff in 1910 was 200.

[LUGOFF SCHOOL, E1, 1920s]. Lugoff School began as a one-room and one-teacher school. In 1905, the school library was established. A wagon was provided to the Lugoff School in 1915 to transport five of its students at an annual expense of $100. Lugoff School was shifted to District #29 by 1919, when J. Sanders was the principal of the 3-teacher school that had 76 students along with a library of 173 books. At that time, Lugoff had a budget of $1, 707. M. McMillen was the 1930 principal of this school.

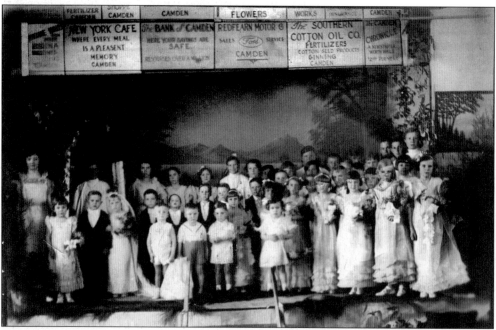

[TOM THUMB WEDDING, LUGOFF SCHOOL, c. 1930s]. In the 1930s, grammar schools enjoyed performing the Tom Thumb Wedding in their auditoriums. Every grade participated and each child would wear the best clothes their family could afford. Some of the expenses of this performance were paid for by displaying signs above the stage for Camden's New York Cafe, Redfearn Motor Company, Southern Cotton Oil Company, The Bank of Camden, and *The Chronicle*.

[EBENEZER METHODIST CHURCH, LUGOFF, *c.* 1930]. Ebenezer Methodist Church was organized in 1850 with its first rectangular frame church structure built in 1850 and in use until it collapsed in 1888 during a revival meeting. The church built their second sanctuary in 1889. The Ebenezer Methodist Church still stands on that site, which is located eight miles northwest of Lugoff on Ridgeway Road (SC #34).

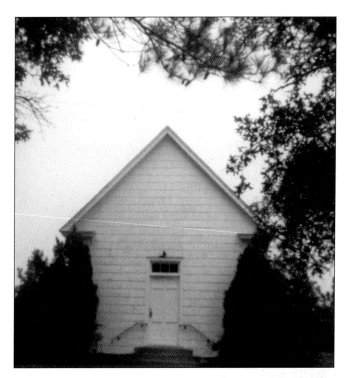

[CRESCENT SCHOOL, E5, *c.* 1920s]. In 1900, Crescent School District #17's white system had three rural one-room schools and three teachers instructing 101 students in a session of 84 days. The teacher for the Crescent School lived in the Dundee Community. The 1910 School District #17's schools had 101 students. By 1919, the Crescent School was shifted into a new School District #39. V.G. Jeter (1918–1920) was the principal of a two-teacher school with 58 students and a total budget of $952. By 1930, S.M. Lucius was the teacher of this one-teacher school. The second site of Crescent School was located on Kennedy Road (KC #627) at Goff Circle, which is south of I20. It still stands in 2002 as a part of Woodrow Goff's residence.

[CONCORD SCHOOL, E7, *c.* 1930s]. Concord School District #38 was funded $553 in 1919 to support two white one-room schools and four African-American one-room schools in the rural area south of Lugoff and west of the Wateree River. The black Concord School, shown above, was located south of Koon Road (KC #405), west of #US 601 and north of the Richland County Line. This Julius Rosenwald Fund school was one of many built in this state. In 1925, South Carolina built 78 new black schools at a partial cost of $479,809 to the state which created 275 black classrooms. The schools ranged from one and two-room rural schools to city high schools with 17 or more classrooms.

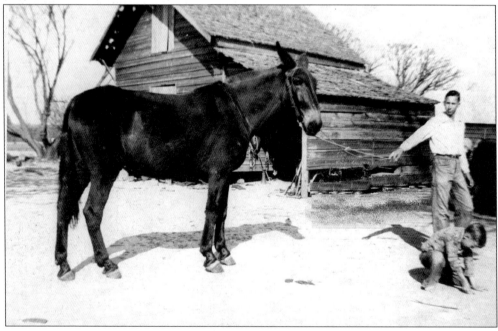

[MILES FARM COMMISSARY, BLANEY, *c.* 1920s]. The barn-like structure behind the mule was the commissary of J.V. Miles's farm at 1526 Porter Cross Road (KC #47) in the early 1900s. Tenants working on the farm could obtain food and necessities from Miles's stock stored in this commissary during the year. The costs of these supplies would be subtracted from the tenant's portion of the harvest after the cotton was sold.

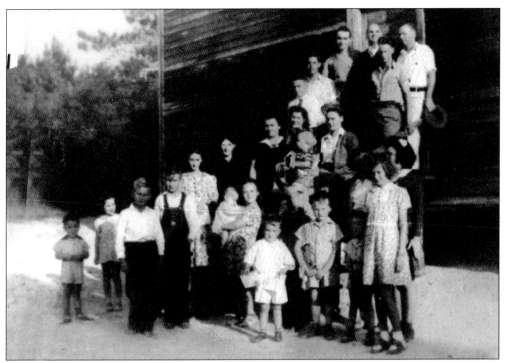

[CONCORD BAPTIST CHURCH, c. 1940]. The Concord Southern Baptist Church was organized in 1909. W.H. Tiller gave a two-acre plot of land for the 35-by-45-foot frame edifice with a belfry and hall. Rev. C.D. Patterson led the church from 1909 until 1912. Concord Baptist Church is located on Porter Cross Road (KC #346) about seven miles south of Lugoff.

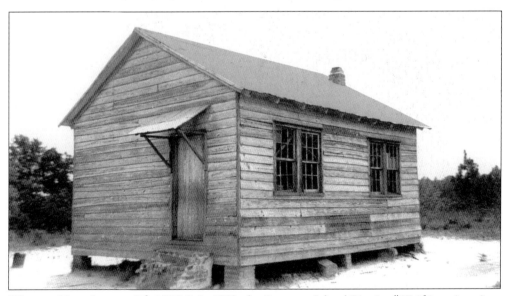

[WEEPING MARY SCHOOL, E6, 1930s]. In 1900, the Crescent School District #17 African-American system had two rural one-room schools (Weeping Mary and Green Hill Schools) and two teachers instructing 193 students in a session of 40 days. In 1910, this district had 170 black students. Weeping Mary School was located on Kennedy Road (KC #627).

[UNION BAPTIST CHURCH, BLANEY, (ELGIN) *c.* 1920s]. The Union Baptist Church was organized in 1861 when Rev. B.C. Ross was the pastor from 1861 to 1862. The first church was built in 1861 and was used until 1911. A 32-by-60-foot sanctuary was erected in 1911. The church is located on Wildwood Lane (KC #349) between Chesnut (KC #927) and Smyrna Roads (KC #21), two miles north of Blaney (Elgin).

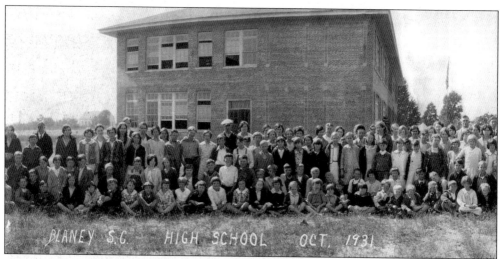

[BLANEY HIGH SCHOOL, (ELGIN) E2, 1931]. The image above is of Kershaw County's new 1931 two-story, brick Blaney High School. Blaney High School became Kershaw County High School District #4 in 1950. The contrast between this 1931 school and a 1900 one-room school shows the growth of Kershaw County's education system. In 1930, the county's white system had consolidated schools into a short list of 3 one-teacher, 11 two-teacher and 5 three-or-more teacher schools with 2,311 students in a 165-day term. The state's highest first-grade certificates were held by 133 of the 146 teachers, while three teachers held second-grade certificates.

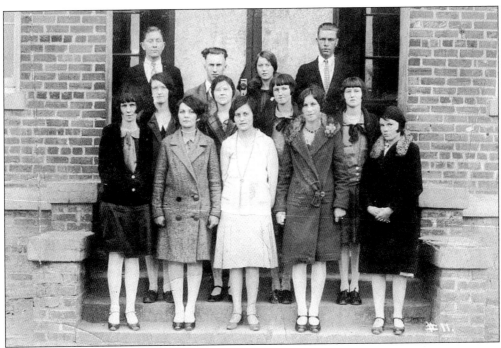

[CLASS, BLANEY HIGH SCHOOL, (ELGIN) E2, 1928]. The Blaney School District #12's 1900 white system had 3 one-room schools with 3 teachers instructing 73 students in an 84-day term. Blaney's library was established in 1907. The three-room, three-teacher 1913 eight-grade school had 117 students in a 100-day term. A new brick school was built in 1915 costing $8,000 and the next year C.G. Williams was the principal of a 244-pupil school. E.W. Rentz was the principal of the 12-teacher 1930 session that had a 165-day term. The population of Blaney in 1910 was 75.

[SEVENTH GRADE CLASS, 1927.] The class picture above shows Blakey High School's seventh grade class with Miss C. Andrea, teacher. In 1935, 1,111 students were transported by 22 buses on a 761-mile round trip per school day at $845 per year. The district also had 12 contract buses that carried 607 pupils on a daily 335-mile round trip at a cost of $965 per year. The 1930 African-American schoolhouses were divided into 26 one-teacher, 13 two-teacher, and 10 three-or-more-teacher schools with 5,487 students in an 86-day term. The 101 county teacher's state certificates were subdivided into 53 teachers with first-grade, 9 with second-grade certificates, and 40 with third-grade certificates.

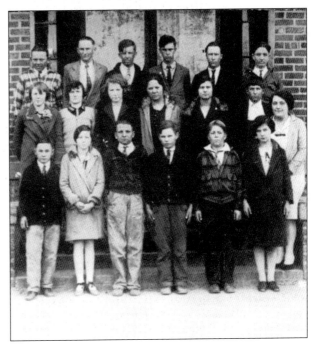

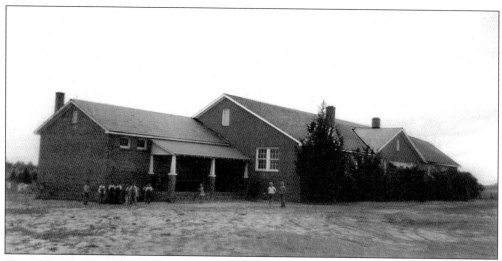

[PINE GROVE SCHOOL, E4, c. 1930]. Pine Grove School District #16's white system of 1900 had 3 schools with 3 teachers instructing 110 students in an 84-day term. Pine Grove had developed into an eight-grade, three-room, two-teacher school in 1913 with 115 students in a 120-day term. Pine Grove expanded to three teachers in 1922 and four teachers in 1924. The site was located on Pine Grove Road (KC #36) near the junction of Nick Watts Road (KC #128).

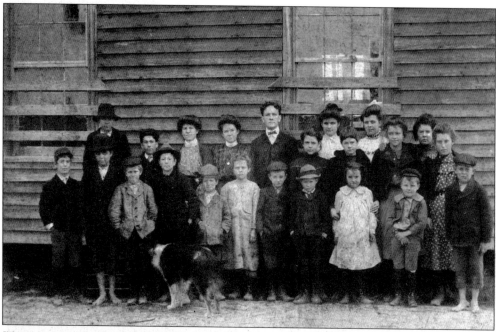

[TRINITY SCHOOL CLASS, E3, 1905]. In 1900, the Trinity School District #11 white system had 4 schools with 4 teachers instructing 158 students in a 96-day term. Trinity School's teacher lived in the Bellfield community. Trinity was a two-room, two-teacher, and ten-grade school in 1913 that had 69 students in a 140-day term. N.P. Gettys, the 1916 principal of the 92-student school, had a wagon to transport 16 students at a cost of $120 per term. Trinity had a library of 150 books. The school was located southeast of Ridgeway Road (SC #34) and Smyrna Road (KC #21).

[**Dr. W.D. Grigsby, Blaney, c. 1900**]. Dr. W.D. Grigsby (1878–1948), son of James A. and L. Grigsby, was born in Kershaw County. Grigsby attended Blaney schools, Leesville College, and received his medical degree from the Medical College of Charleston. He married L. Burns of Charleston. Grigsby was a beloved doctor who practiced medicine in Blaney for 42 years.

[**Smyrna Methodist Church, 1930s**]. The Smyrna Methodist congregation was organized in 1810 and purchased eight acres from N. Melton for $10. The sanctuary was damaged in 1865 by Union troops. The church site is located by Ridgeway Road (SC #34) on Smyrna Church Road (KC #362).

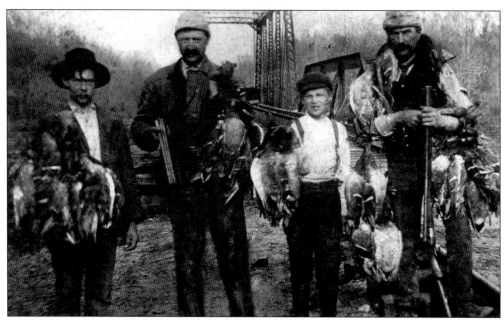

[DUCK HUNTERS AT THE TRESTLE, c. 1930s]. Duck hunters, B. Scott, second from left, and L. Whit Boykin, far right, stand with two train passengers and a display of ducks they shot on a successful duck hunt on the Wateree River. After the hunt, they crossed the railroad trestle to catch the train home. Boykin and A.L. White, of Spartanburg, wanted a small dog for hunting. They originally started breeding the Boykin Spaniel—South Carolina's State Dog—to flush turkeys. The breed is now used to retrieve ducks and doves.

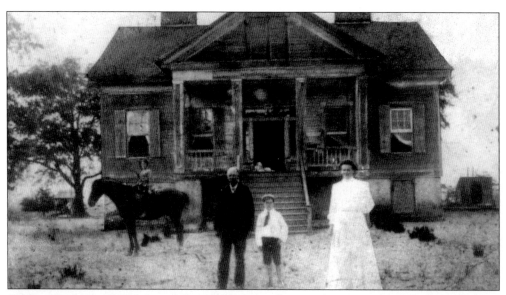

[MICKLE HOME, c. 1920s] Capt. J.N. Mickle's home was on the west side of the Wateree River south of Shawney's Creek. The Mickle home was a summer retreat for grandchildren, nieces, and nephews who spent quiet, leisurely days having picnics and swimming, fishing, and playing together. The evenings were filled with stories of the days before the Civil War when times seemed to be full of happy events. The house was destroyed by fire in 1928.

[**Mt. Joshua Methodist Episcopal Church**, *c.* **1930s**]. Mt. Joshua Methodist Episcopal Church was organized in 1870 with Rev. J. Brown as the pastor. A log structure was built in 1870 and the first frame structure was erected in 1890, when there were 200 members. This building was torn down and rebuilt in 1914. The congregation had 50 members in 1932. It is located on Longtown Road (KC#5) west of Sawney's Creek, near the Fairfield County line.

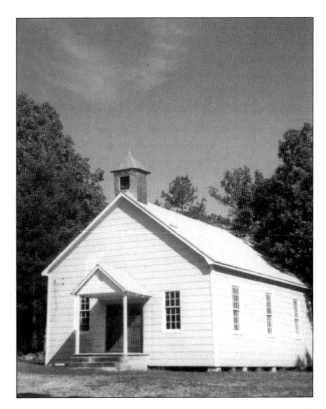

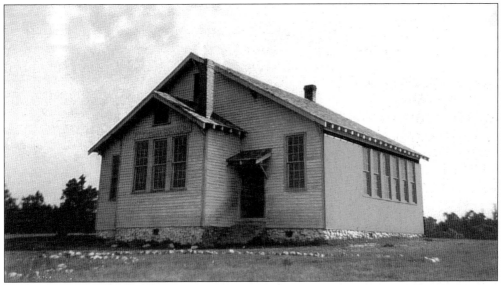

[**Mt. Joshua School, E9**, *c.* **1930s**]. The Pine Grove District #16's African-American School system of 1900 had 5 schools with 5 teachers instructing 240 children in a 70-day term. The schools were Mt. Joshua, Mickle, Parker, Wateree, and Woods. In 1913, Mt. Joshua was a one-room school for 30 students in 5 grades in a 52-day term. The teacher made $65 a year. The initial building was replaced by a modern facility in the 1930s. The old structure was located on Longtown Road west of Sawney's Creek by the Mt. Joshua Church. It no longer stands.

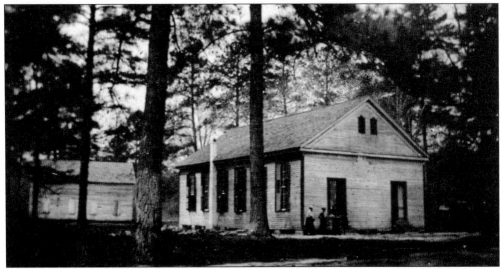

[EPHESUS CHURCH, SCHOOL IN BACKGROUND, C. 1910]. Miss Callie Perkins bought Singleton Plantation in 1857. She allowed slaves to meet at the head of a branch, now known as Buck's Crossing, where they prayed and sang songs under a bush arbor. After the Civil War, the ground they used for their services was granted to them. They constructed a small building in 1869, which was later razed and a new one was built in 1872. The Ephesus Church leader, G. Bennett, directed the congregation to join the S.C. Methodist Conference. The site of the Ephesus Church, School, and Cemetery is located by Lachicotte Road (KC #133) and Friends Neck Road just north of I-20 and (US #601) exit #92.

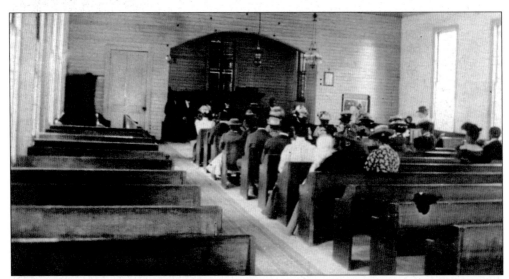

[EPHESUS METHODIST CHURCH, INTERIOR, C. 1910]. The Mather Academy teachers took trips to Ephesus to lead the church members, who were former slaves and children of slaves, in church services, music, and Bible study to help develop their understanding of Christian teachings. Mrs. Russell bought an organ for the church in order to improve their music and singing skills. The first settled pastor was Rev. J.W.S. Brown. In recent years, Ephesus merged with Smyrna Methodist Church. They called themselves Unity United Methodist Church and decided to use Smyrna's Church building on Fort Jackson Road in Lugoff.

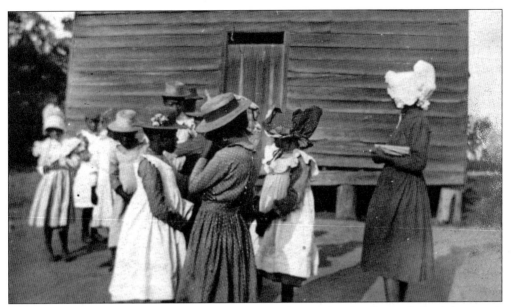

[EPHESUS SCHOOL FRONT AND CHILDREN, E8, *c.* 1910]. The simple schoolhouse behind the church was used to teach both the children and the adults basic reading and writing skills, which had been denied them previously. The Mather Academy teachers showed them fundamental plantation skills so they would be able to obtain agricultural jobs and taught them skills that would help them relate to the evolving life experiences and customs.

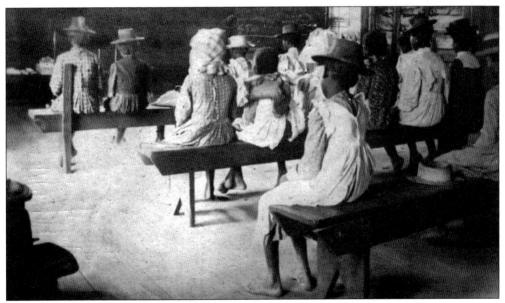

[EPHESUS SCHOOL, INTERIOR, E8, 1910]. Before the Civil War, it was illegal to teach slaves to read, write, or have any educational skills that could assist them in escaping from their owners. Former slave children and adults in backwoods rural areas were denied rudimentary educational skills. After emancipation, freedmen were anxious for their children to be educated. In 1913, Ephesus was in the Lugoff School District #12. This one-room school had 100 students in 5 grades in a 60-day term. The teacher earned $90 a year.

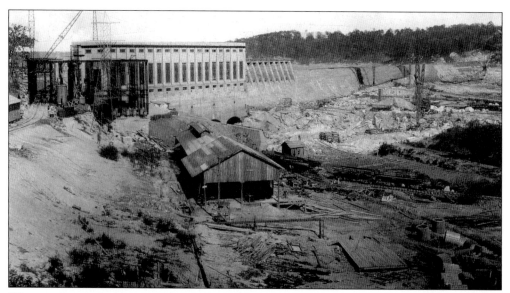

[WATEREE DAM CONSTRUCTION, 1918]. The Southern Power Company awarded a 1917 contract to the Hardaway Construction Company in Columbus, Georgia to build a half-mile dam across the Wateree River, at a site eight miles northwest of Camden for a cost of nearly $6,000,000. Hundreds of men were employed, a branch railroad track was built to the site from Lugoff, and a concrete plant was built at the site. The Wateree hydroelectric power station began operation on September 14, 1919 with five turbines that could produce 20,000 horsepower each for a total power resource of 100,000 horsepower or an annual yield of 180,000 Kilowatt-hours. The dam created a lake 20 miles long with many recreational advantages.

ACKNOWLEDGMENTS

Many people and institutions have contributed to the preparation of this book. We wish to express our gratitude to Allen Stokes, Beth Bilderbeck, Robin Copp, and Thelma Hayes of the South Caroliniana Library, University of South Carolina. Other essential contributions were made by Agnes Corbett and staff of The Camden Archives and Museum; Steve Tuttle, South Carolina Department of Archives & History; Joan and Glen Inabinet; Joanna Craig, The Historic Camden Revolutionary War Site; Charles Baxley and members of the Kershaw County Historical Society; Marty Daniels; Martha W. Daniels; John H. Daniels; Archives, Mulberry Plantation; Beth Inman, Confederate Museum; and Hope Cooper, National Steeplechase Museum.

Other contributions were made by Lance Anderson, Alice Boykin, Doris G. Brown, Judge Bill Byars, Mary E. Cunningham, Panda Douglas, Shannon DuBose, Miles Gardner, John F. Gilbert, Woodrow Goff, Marietta W. Gordon, Van Green, Elizabeth P. Hough, Sylvia Hudson, Mr. and Mrs. Joseph Jenkins, Paul Jeter, Kershaw News-Era, Anne H. Lloyd, Esther McCaskill, Mike McClendon, Susan McMillian, Kenny Miles, Lula Miles, BeBe Myers, Max O'Cain, Richland County Public Library; Austin Sheheen, Lynette M. Smith, Mildred Smith, Andee Steen, Gail Wagner, and Paula Woodlief.

Major historical references were *Historic Camden, Volumes 1 and 2* by T. J. Kirkland and R. M. Kennedy; Annual Report, State Superintendent of Education, 1900–1950; *Camden Chronicle*, 1890–1935; *Camden Heritage, Yesterday and Today* by Rachel Montgomery; *Kershaw County Legacy, A Commemorative History*; Kershaw County Bicentennial Commission, 1976, and *Legacy Volume II*, 1983 by Glen and Joan Inabinet.

INDEX